— THE —
BOTANICAL FOOTWEAR
OF DENNIS KYTE

By Dennis Kyte

Foreword by Dodie Kazanjian

S EDITIONS

COPYRIGHT ©1998 DENNIS KYTE

S EDITIONS IS AN IMPRINT OF SMITHMARK PUBLISHERS

THIS EDITION PUBLISHED IN 1998 BY SMITHMARK PUBLISHERS
A DIVISION OF U.S. MEDIA HOLDINGS
115 WEST 18TH STREET, NEW YORK, NY 10011

SMITHMARK BOOKS ARE AVAILABLE FOR BULK PURCHASE FOR SALES
PROMOTION AND PREMIUM USE. FOR DETAILS WRITE OR CALL THE
MANAGER OF SPECIAL SALES. SMITHMARK PUBLISHERS,
115 WEST 18TH STREET, NEW YORK, NY 10011

DISTRIBUTED IN THE U.S. BY
STEWART, TABORI & CHANG
A DIVISION OF U.S. MEDIA HOLDINGS, INC.
115 WEST 18TH STREET, NEW YORK, NY 10011

PRODUCED BY
SWANS ISLAND BOOKS
BELVEDERE, CALIFORNIA

BOOK DESIGN BY
MADELEINE CORSON DESIGN
SAN FRANCISCO, CALIFORNIA

LIBRARY OF CONGRESS CATALOGING–IN–PUBLICATION DATA

KYTE, DENNIS, 1948–
 BOTANICAL FOOTWEAR OF DENNIS KYTE.
 P. CM.
 "A SWANS ISLAND BOOK."
 ISBN 1-55670-853-X (ALK. PAPER)
 1. KYTE, DENNIS, 1948– --THEMES, MOTIVES. 2. VEGETABLES IN ART.
3. PLANTS IN ART. I. TITLE.
ND237.K98A4 1998 98-23422
759.13--dc21 CIP

PRINTED IN HONG KONG
10 9 8 7 6 5 4 3 2 1

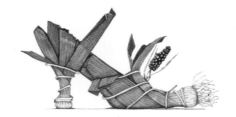

The first time I opened this ever-green book, I stepped into the Mediterranean Islands wearing olive slippers, experienced the four seasons, got high on jasmine, saw a shoe—but didn't dare try it on—that had a pickle for a heel, and found out the truth about love from a gossiping daisy. That was enough for one sitting. But I was curious, so the next day I opened it up again, only to find myself traveling the continents in eggplant-and-sunflower mules. It was a bit uncomfortable because a persistent beetle was perched on my big toe the whole way, but this time I met an artichoke who shared its heart with me, and I had an argument with a rose, the bully of the garden, who had the last word.

Dennis Kyte has created a magical world with his effervescent drawings and fantastical words. This is a book for all seasons, a contemporary Book of Hours, one part travel, one part philosophy, and ten parts fun.

DODIE KAZANJIAN

As an artist I embark on a journey. Before any image becomes reality, I find myself drawing upon memory, historical reference, my senses, and especially nature. Ideas flow from quiet walks, travels to exotic locations and very often, from simply a fragrant stir at my studio window. A New England breeze carries the scents of jasmine, orange, hyacinth or rose. I am compelled to draw. Mounds of blank paper spill over with a visual feast of flowers, fruits, vegetables and vines. ❧ At first, this artist's thicket of imagination is confounding and random. I look for a clearing, a direction that will add form to nature's beauty. I remember the silhouette of a court

pump, a shoe fashioned in a French garden instead of at a cobbler's bench.

Suddenly, a natural pathway is obvious and my work evolves with each step.

The mode of mental transport is literally on foot. There is surprise and

style and above all, an everchanging vision of an elegant slipper. ⤳ Within

this folio of botanical footwear, I invite you to travel through the open gates

of secret gardens, winding—as I do—among the lush fields of sensory imagi-

nation. As you wander through this book, expect to feel an iris blossom, to

see the scent of ripe tangerines, to hear the whisper pink color of roses.

But remember to watch your step! It all changes before your eyes.

———

DENNIS KYTE

...ARTISTS FEEL AT HOME

IN THE LUMINOUS SPILL OF SENSATION,

TO WHICH THEY ADD THEIR OWN

COMPLEX SENSORY NIAGARA.

———

DIANE ACKERMAN

A Natural History of the Senses

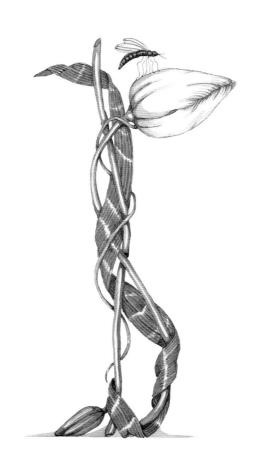

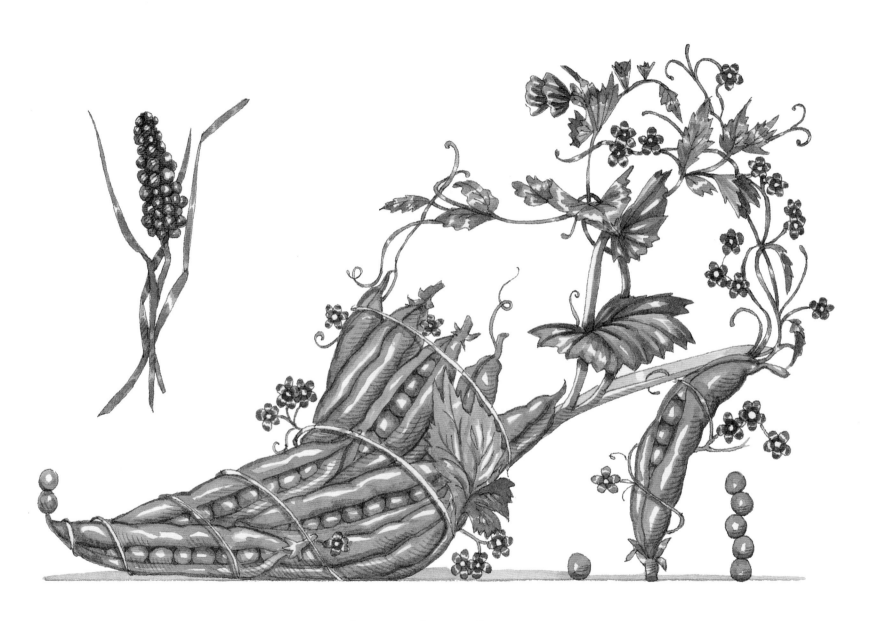

Peas & Grape Hyacinth

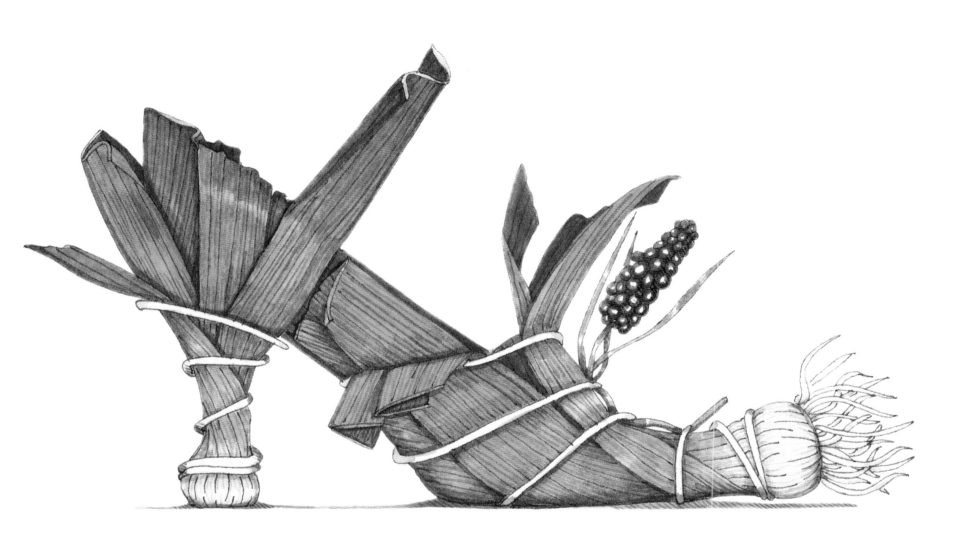

Leek & Grape Hyacinth

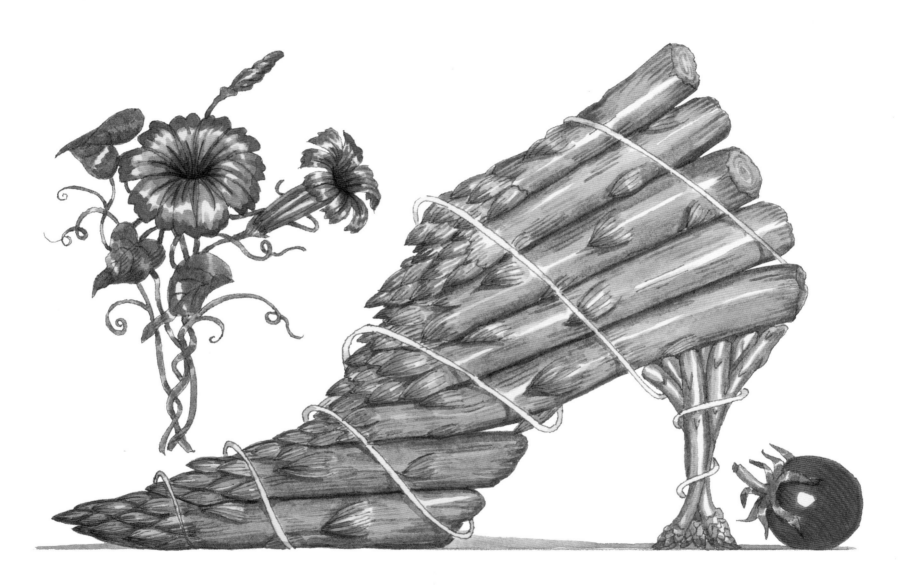

Asparagus & Tomato

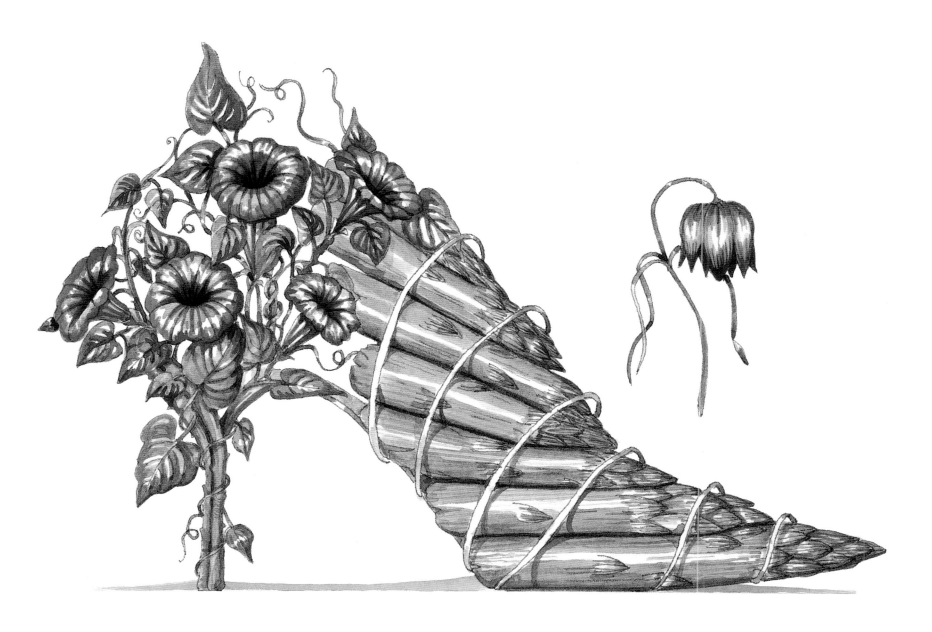

Asparagus & Morning Glory

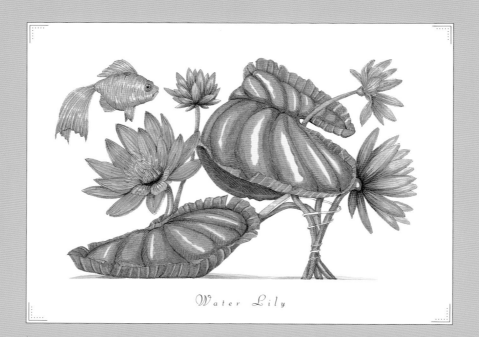

Water Lily

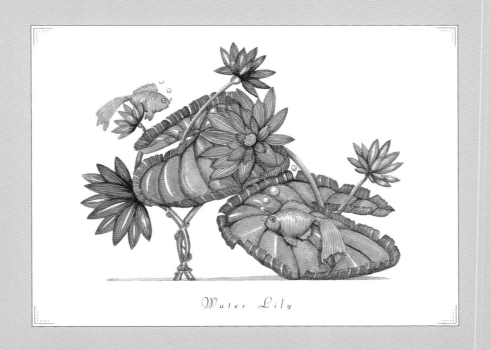

Water Lily

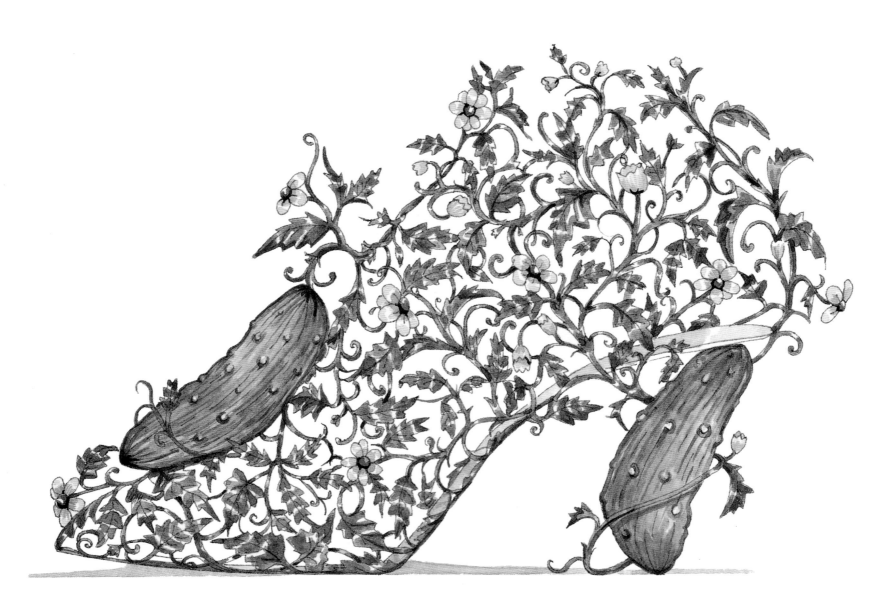

Cucumber Pickle

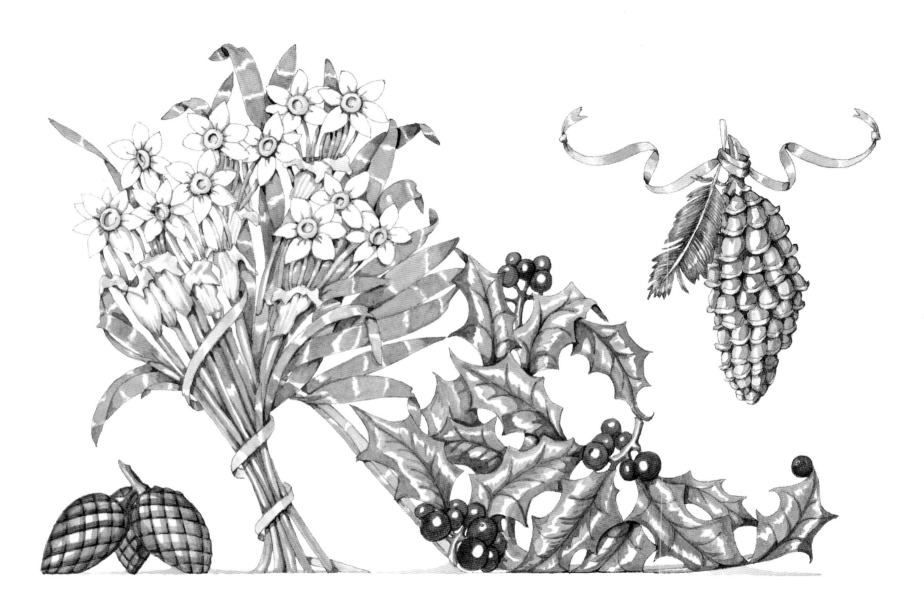

Narcissus & Holly

Green

HAS MORE TO DO WITH

intoxication

THAN IT DOES

envy.

❧

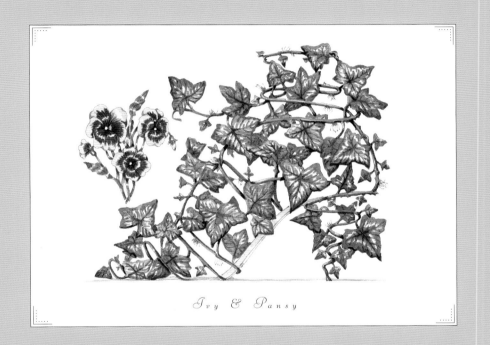

Ivy & Pansy

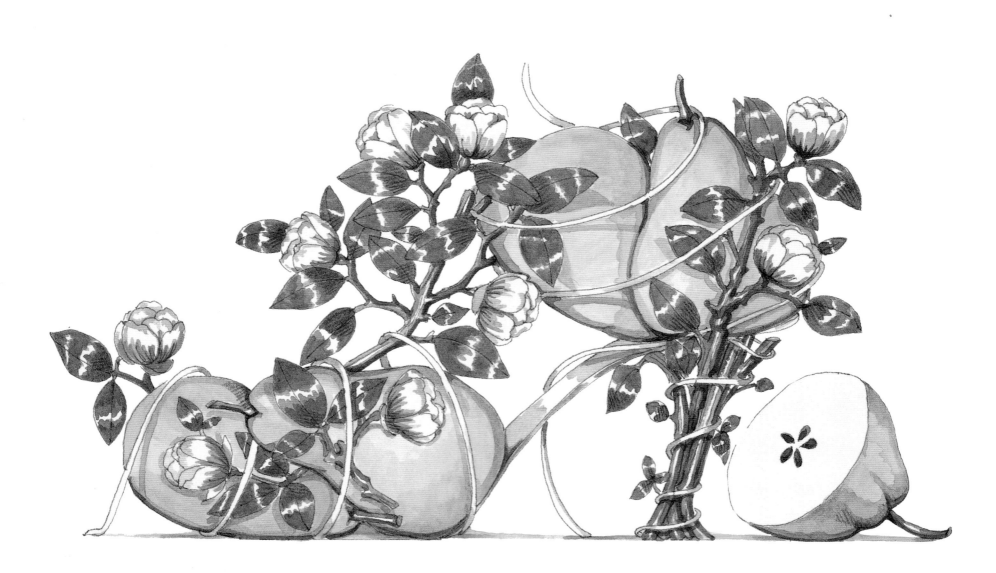

Pears

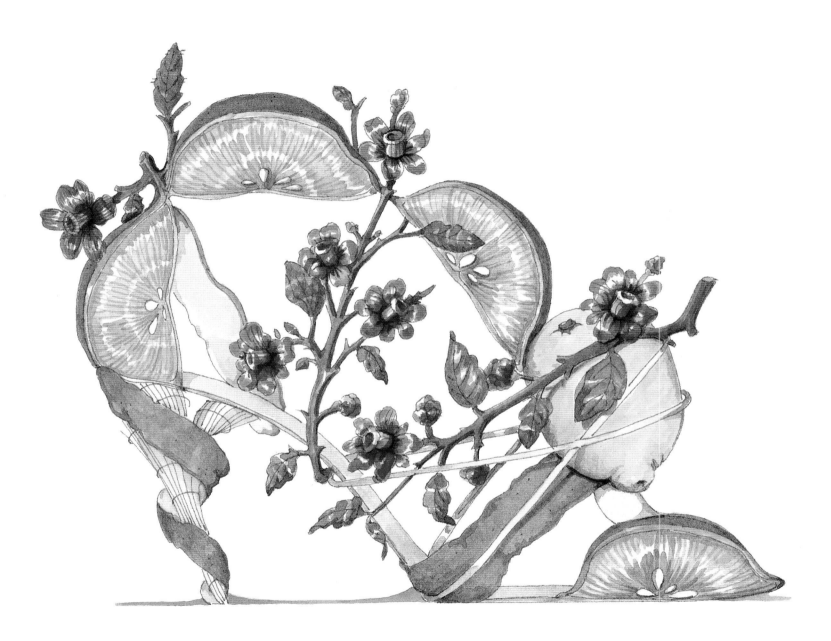

Lemon & Lime

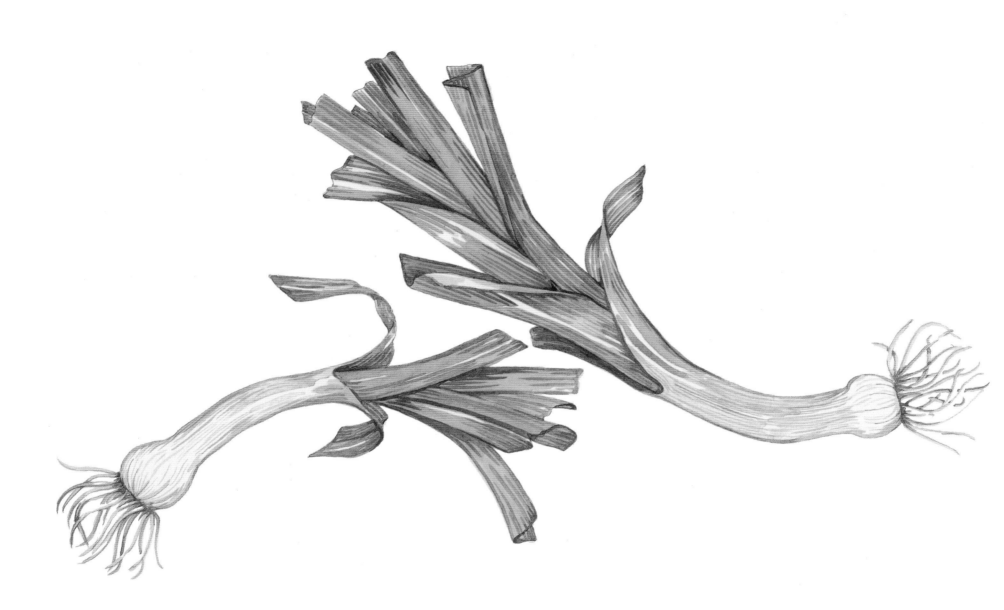

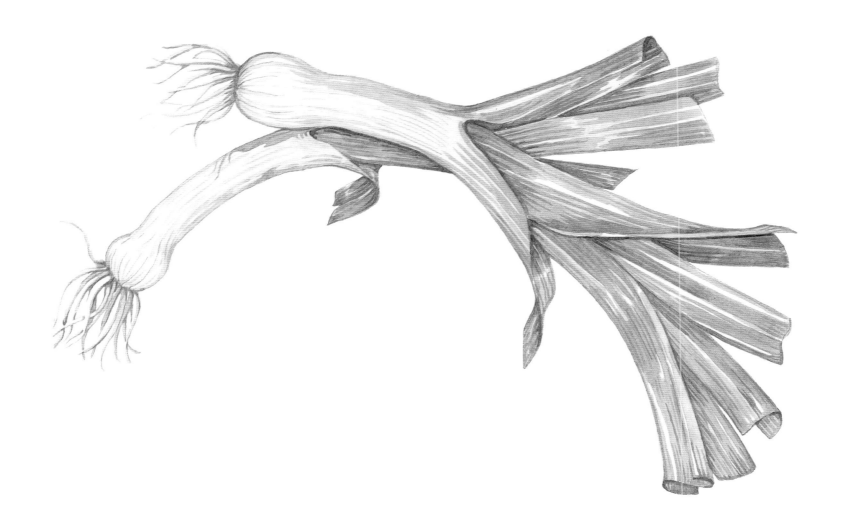

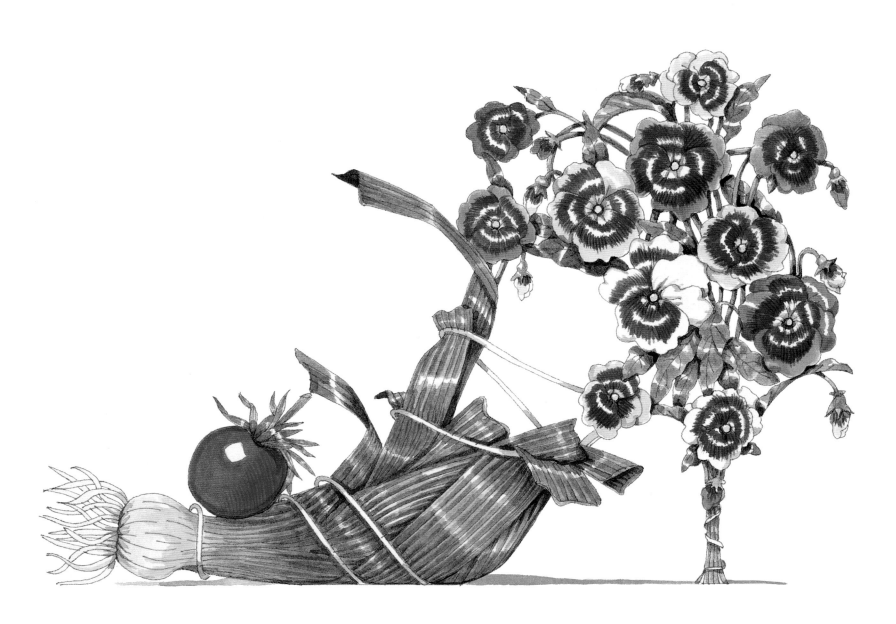

Leek & Pansy

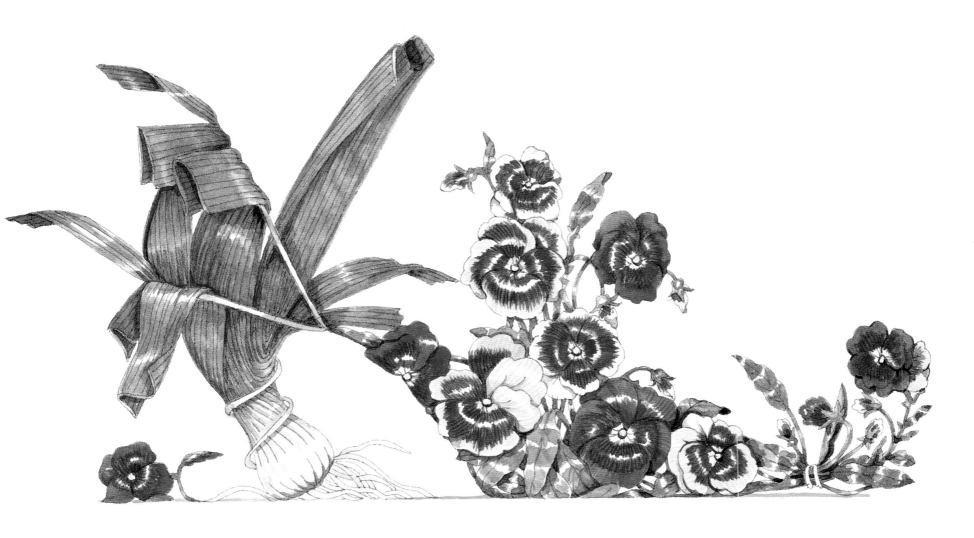

Leek & Pansy

PAIRS

alwa

PERFECT

. . . NOT

y s a

MATCH

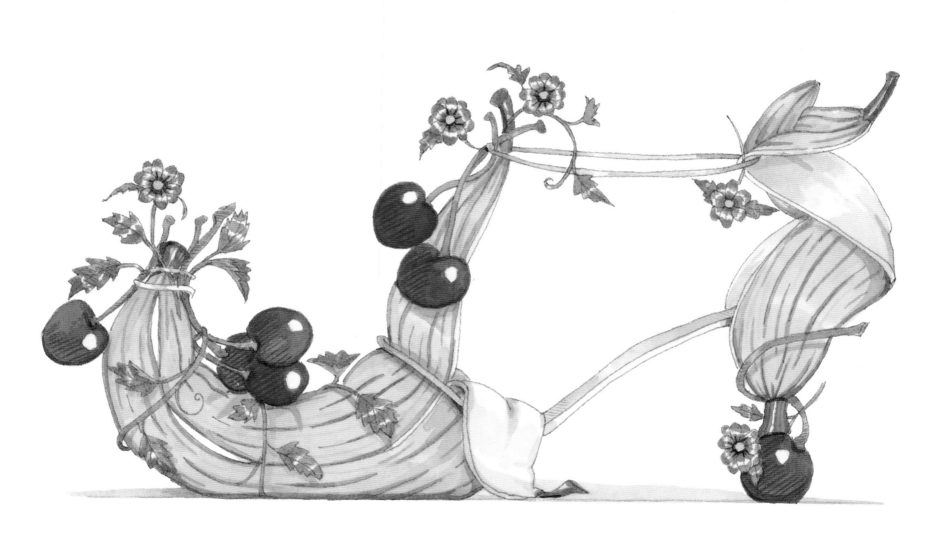

Banana & Cherry

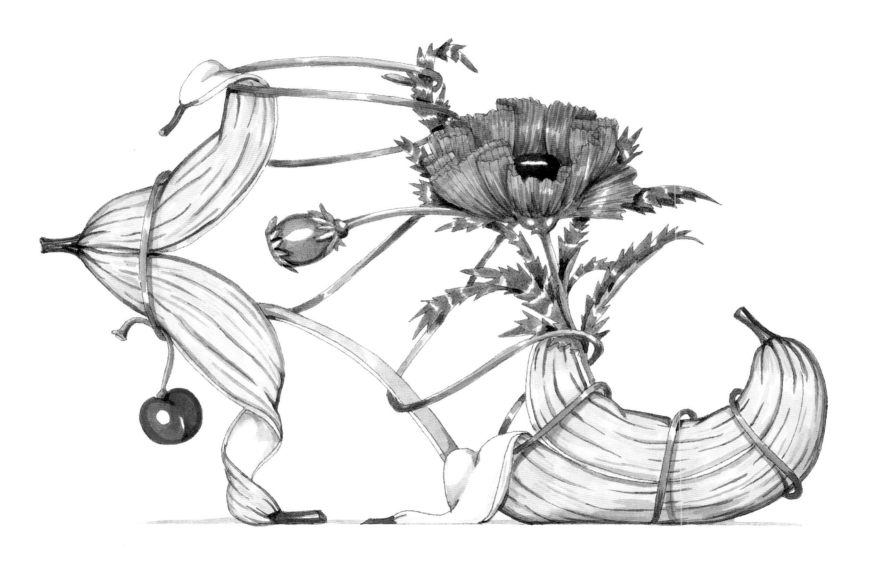

Banana & Cherry

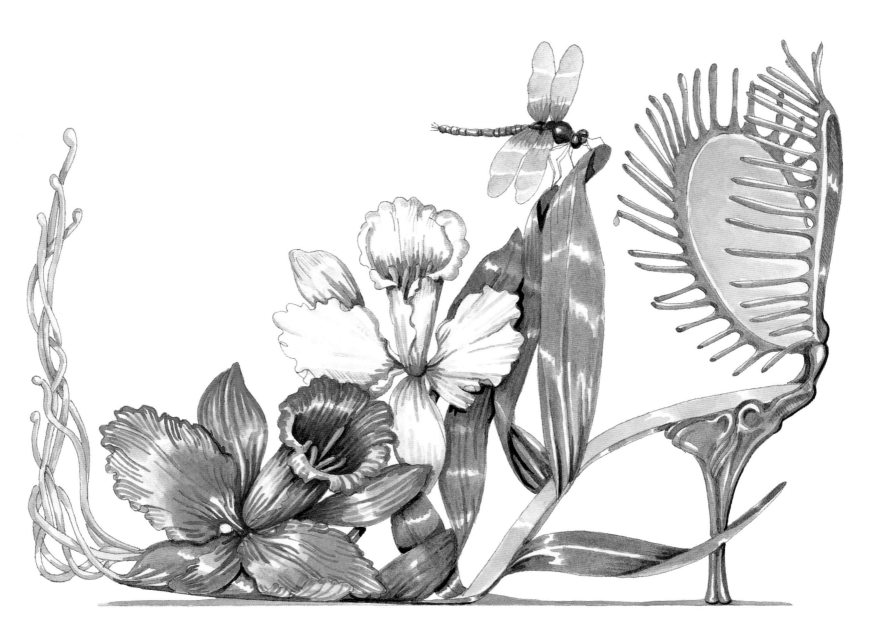

Orchid & Venus Fly Trap

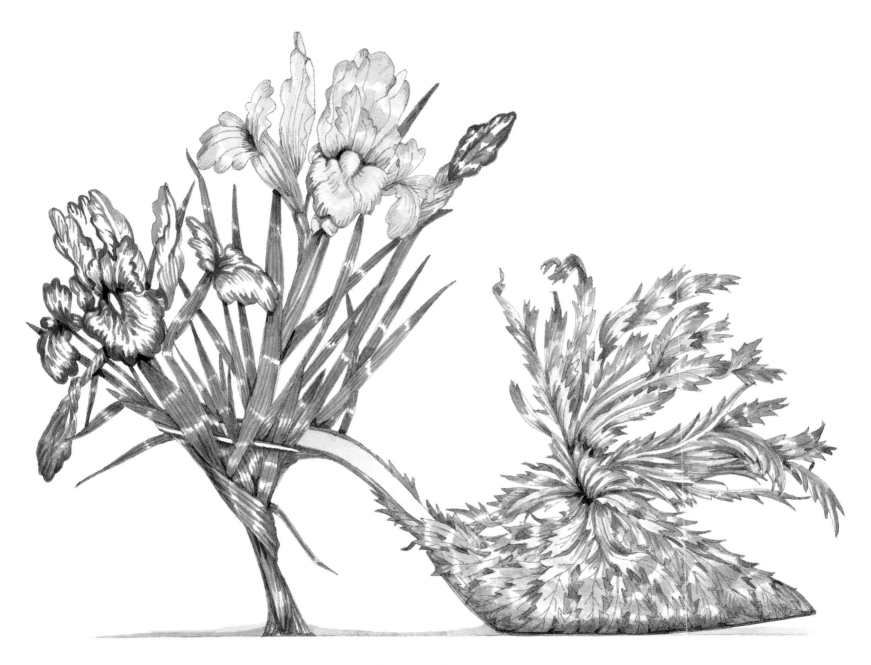

Iris & Escarole

To feel

NOT AS TWO,

but at one

WITH THE SEA.

꩜

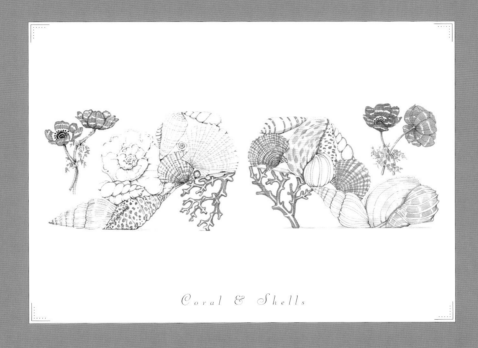

Coral & Shells

Heel toe, heel toe. Aubergine, do you know? The seeds you seek are the seeds you know.

⚜

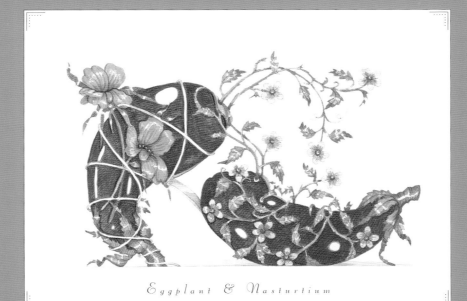

Eggplant & Nasturtium

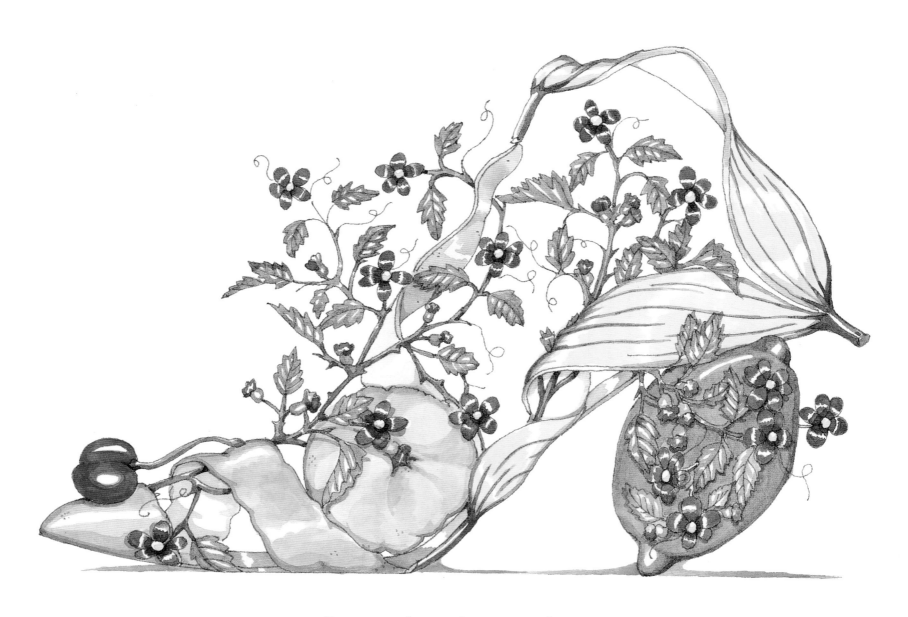

Banana, Lime, Orange & Cherry

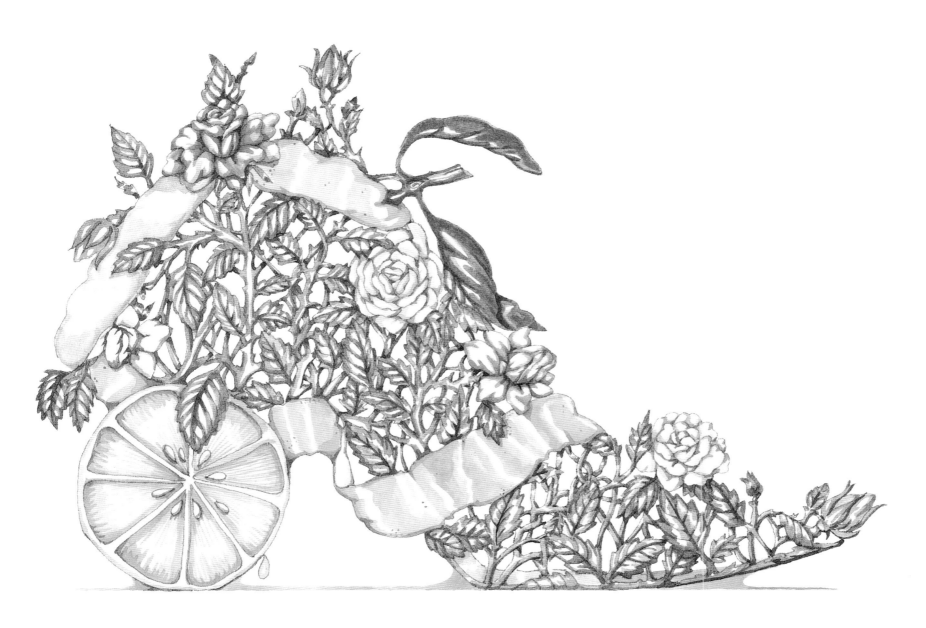

Orange & Rose

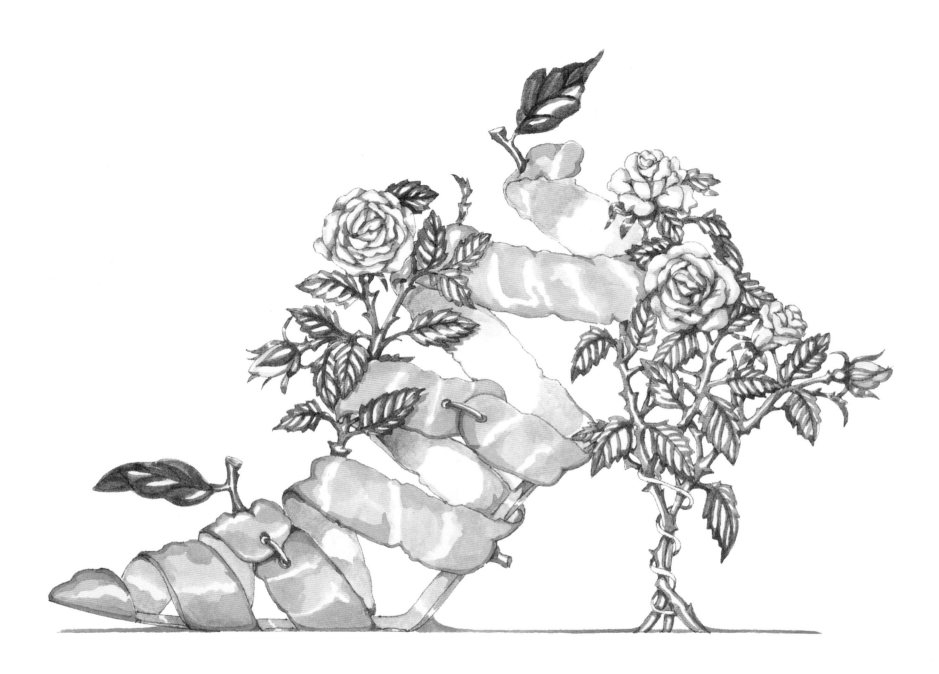

Orange & Rose

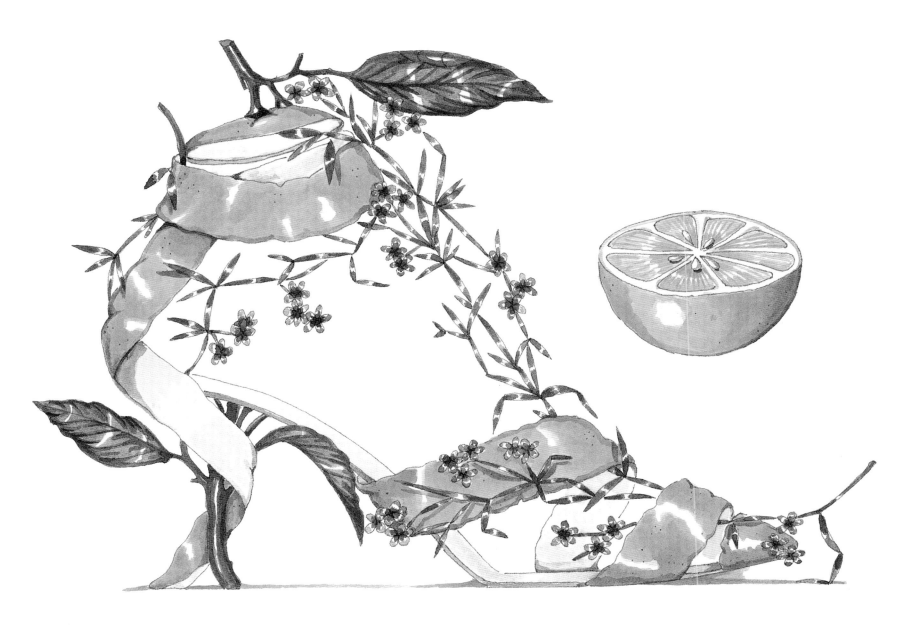

Orange & Lavender

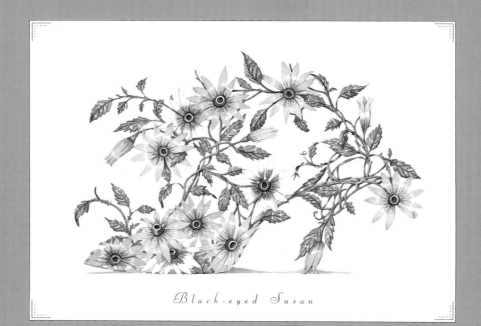

Black-eyed Susan

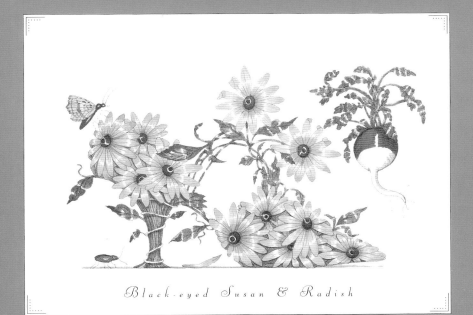

Black-eyed Susan & Radish

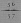

When

TWO HEADS

are better

THAN ONE?

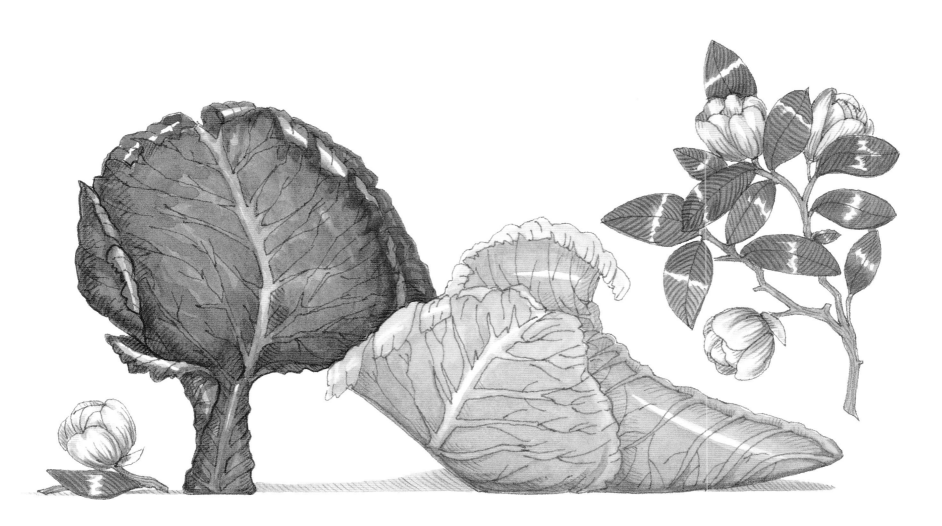

Cabbage

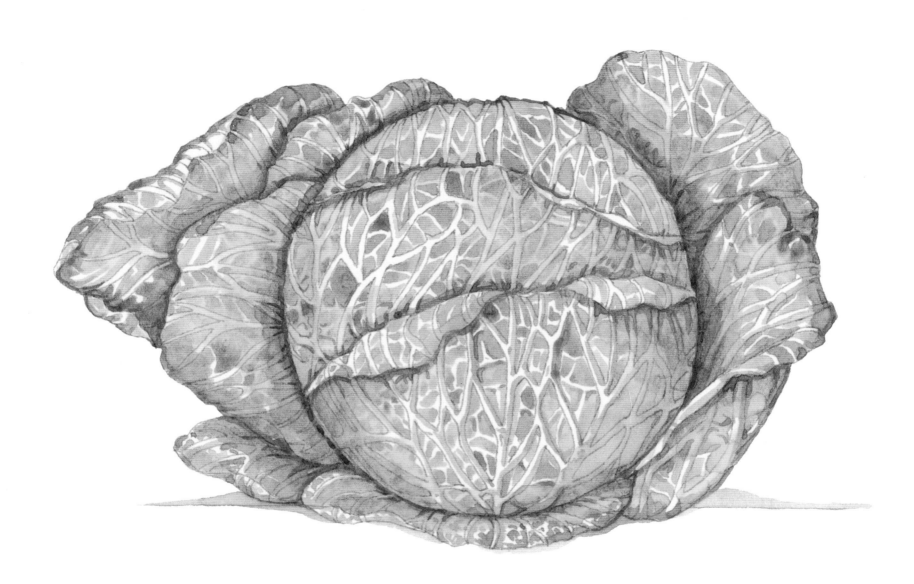

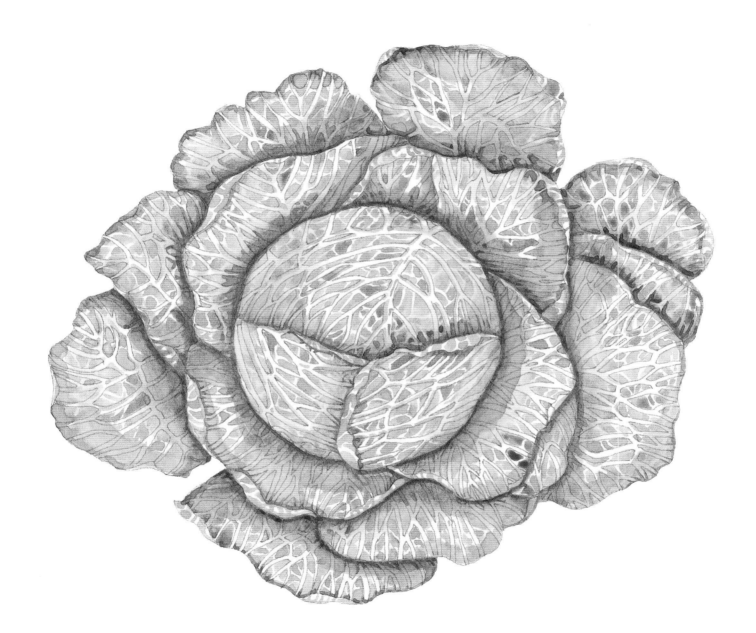

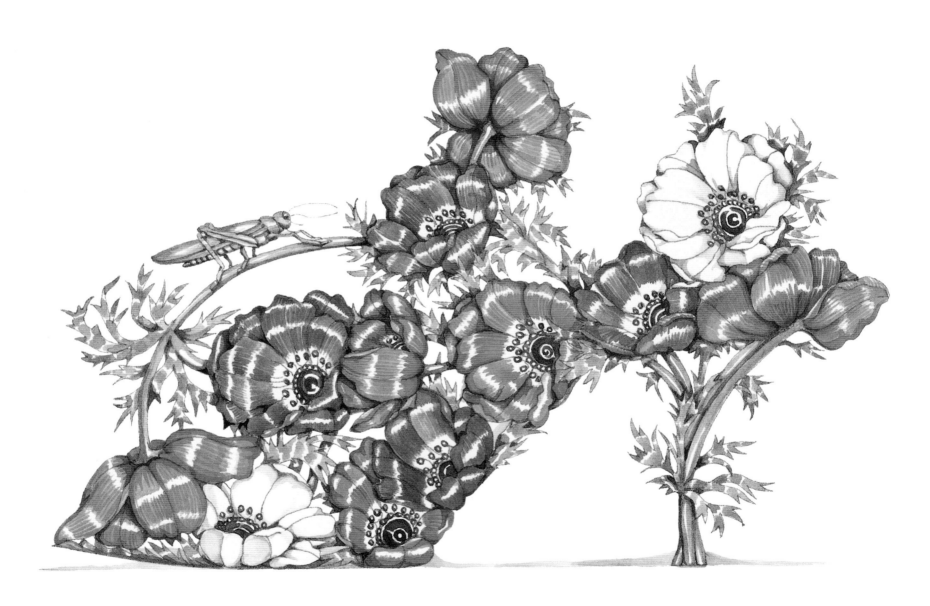

Anemone

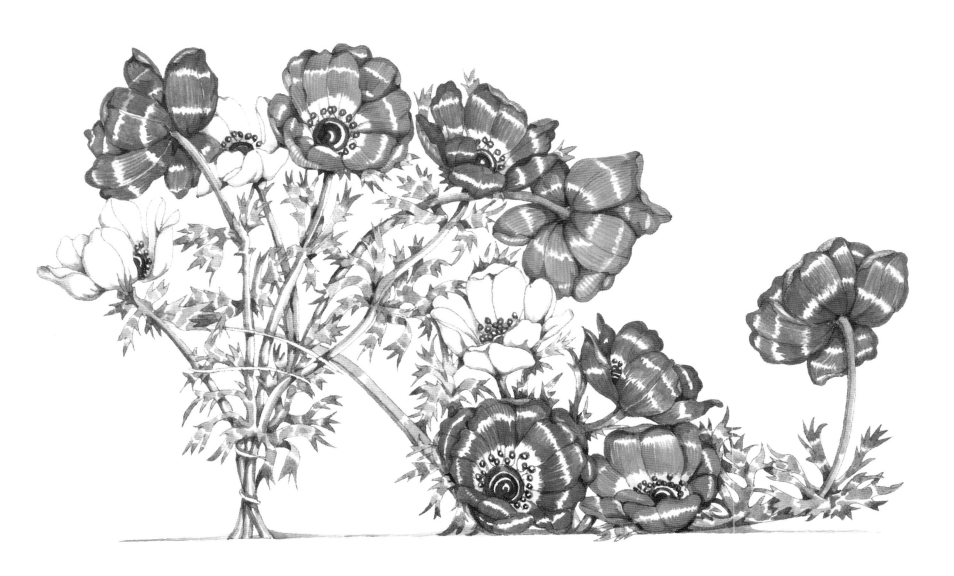

Anemone

Like

TWO PODS

with two

AND TWENTY PEAS.

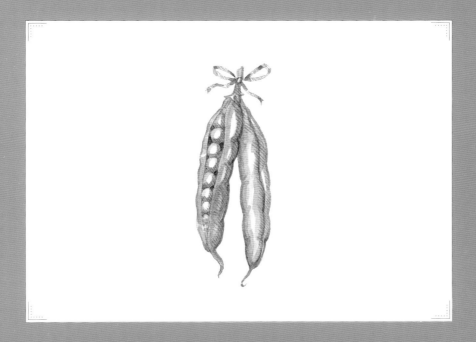

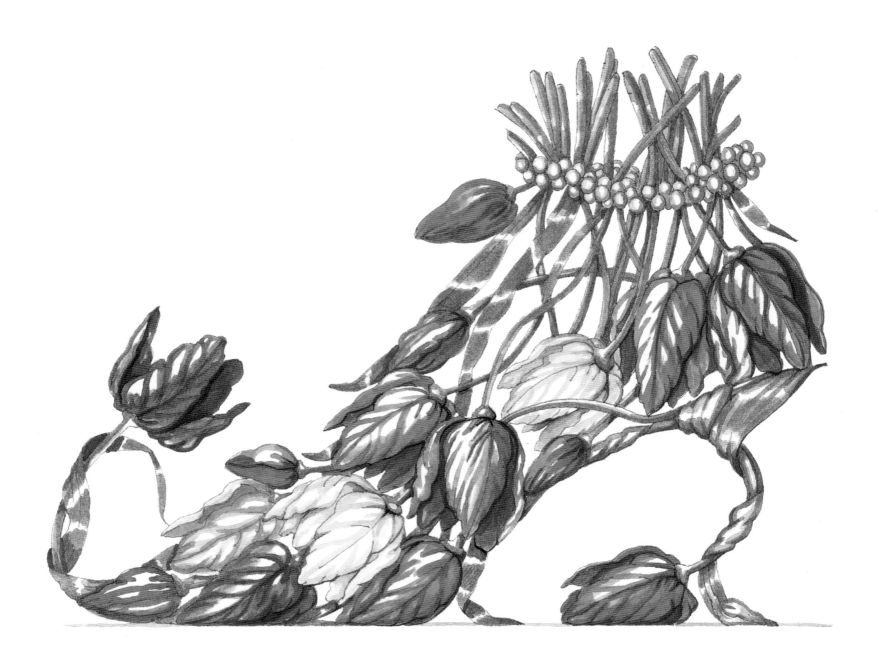

Tulip

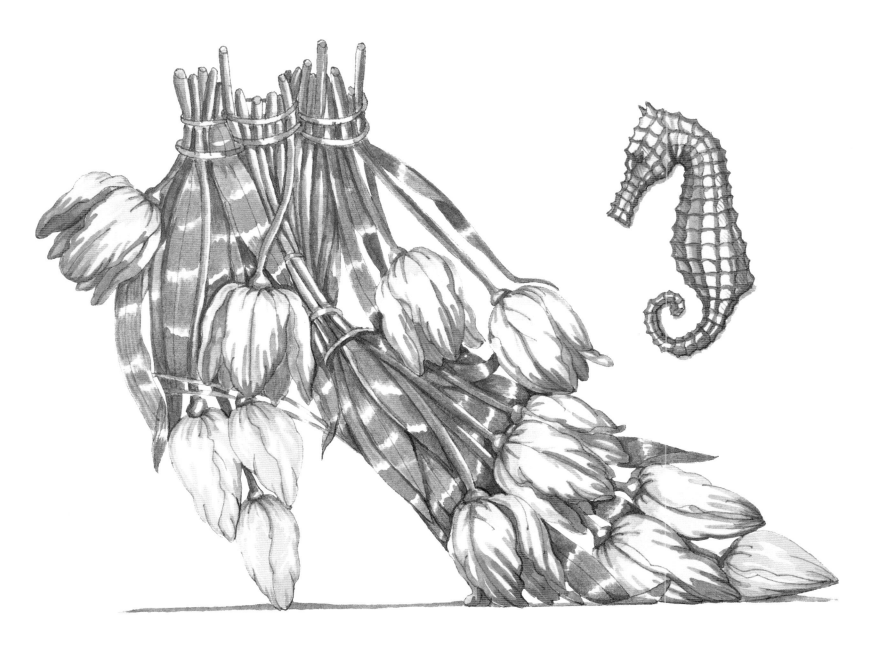

Tulip & Sea Horse

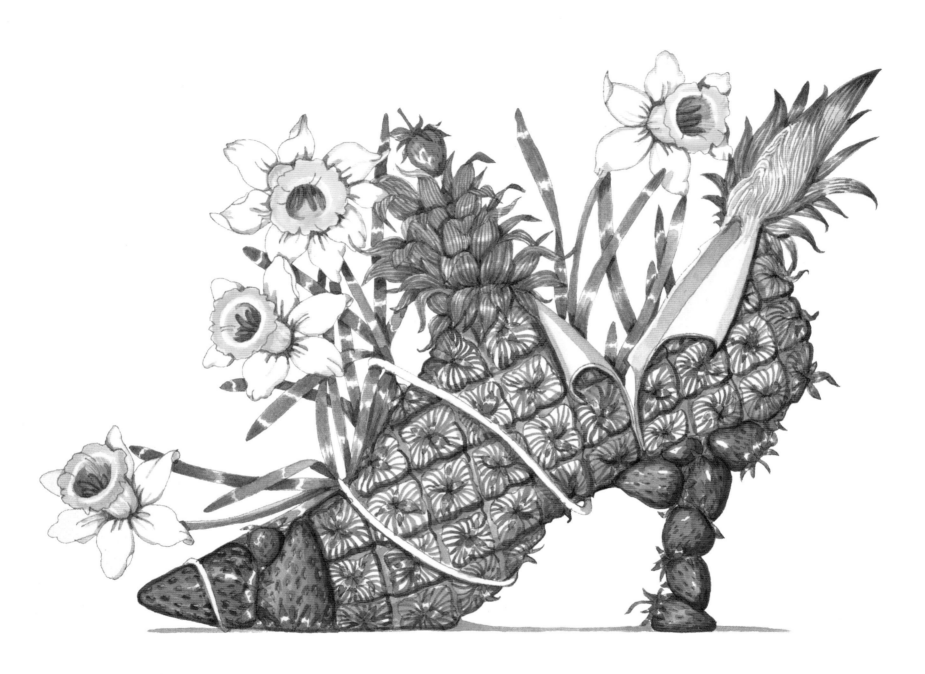

Pineapple & Daffodil

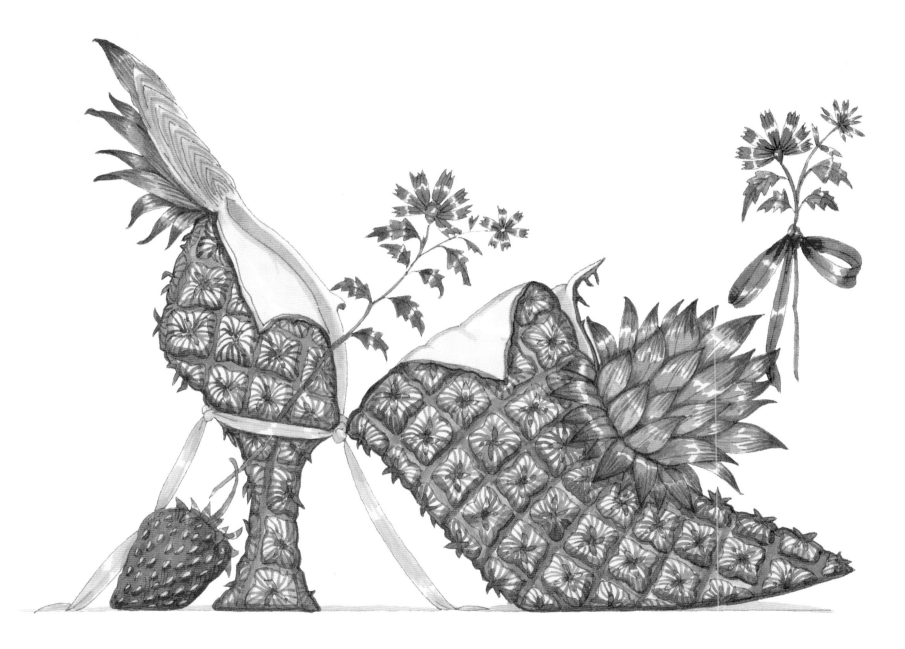

Pineapple & Strawberry

THE
Z

o f

n

TO A

ture

$\frac{72}{73}$

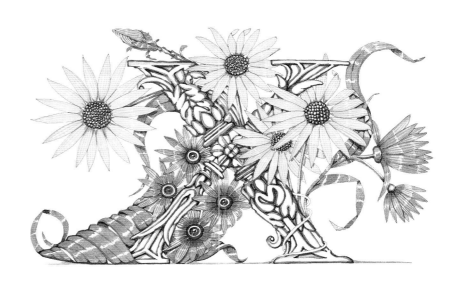
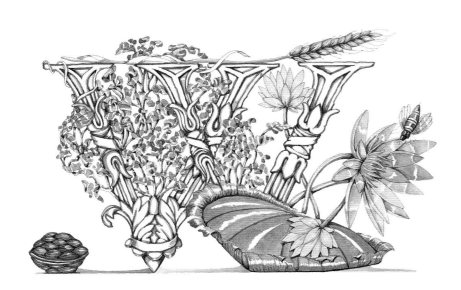
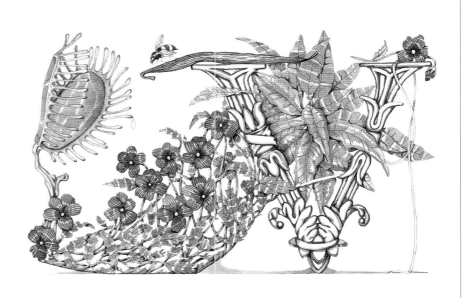

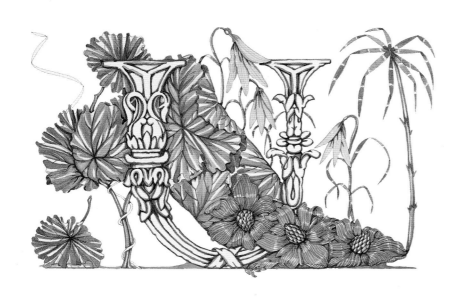
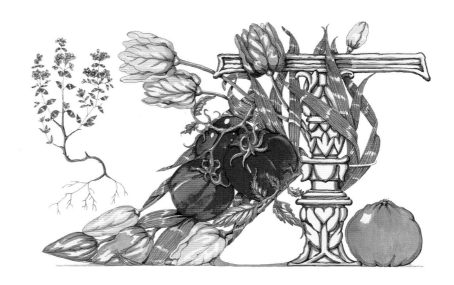
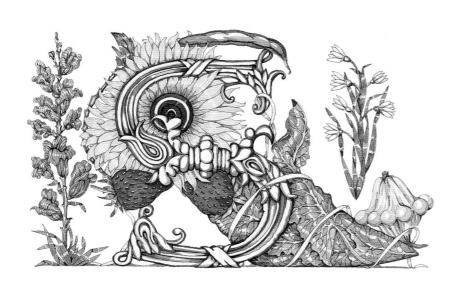
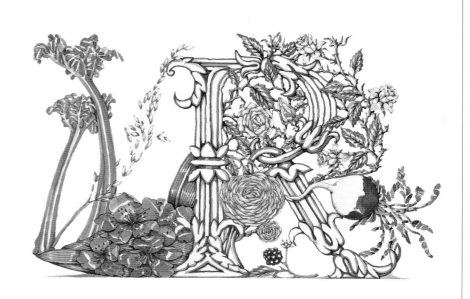

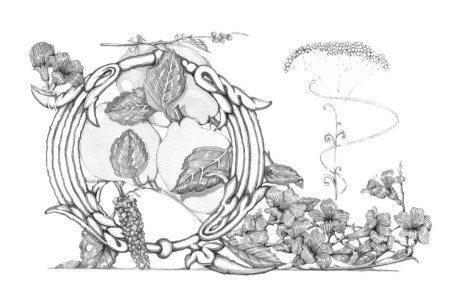

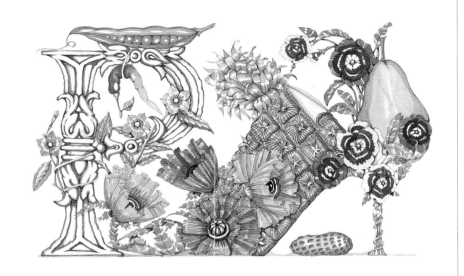

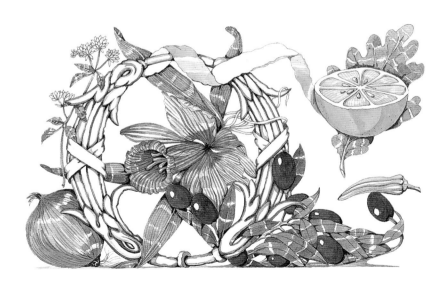

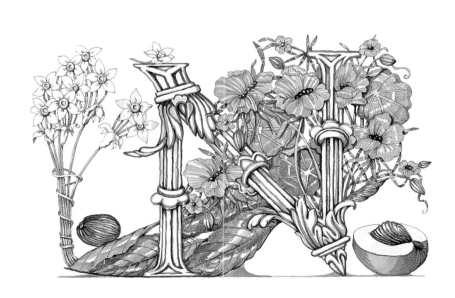

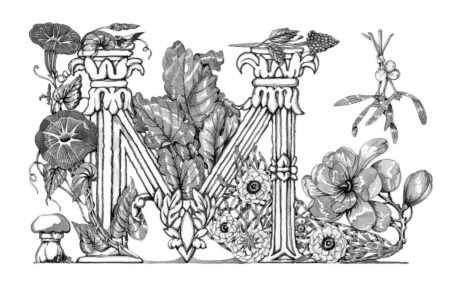

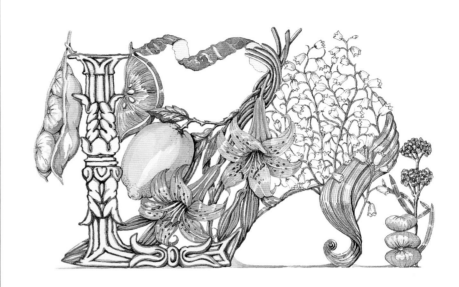

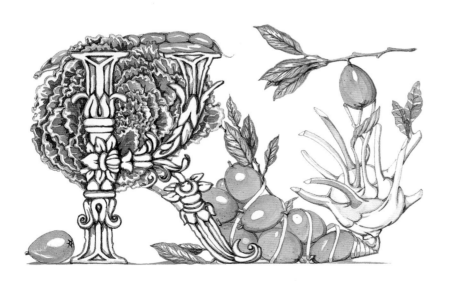

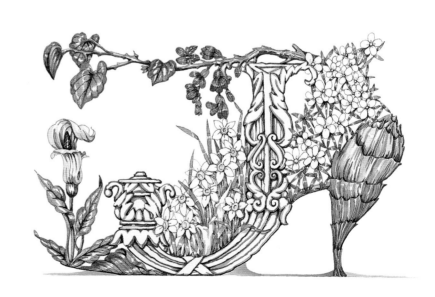

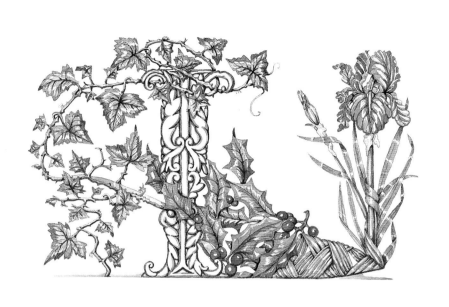

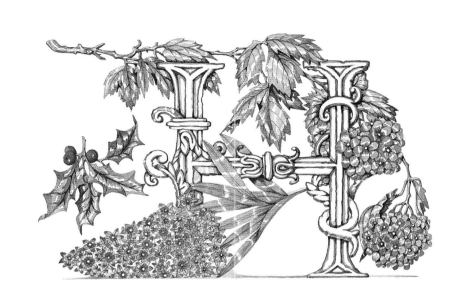

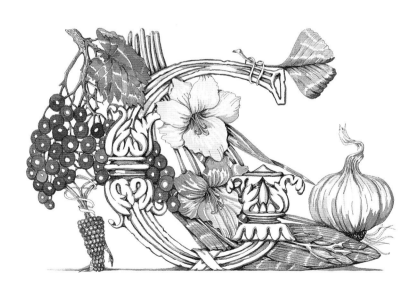

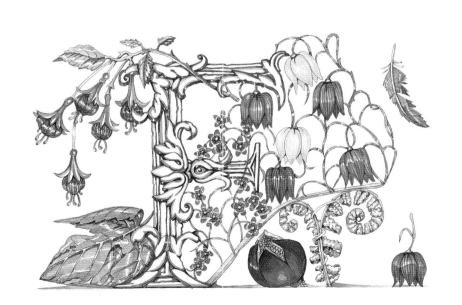

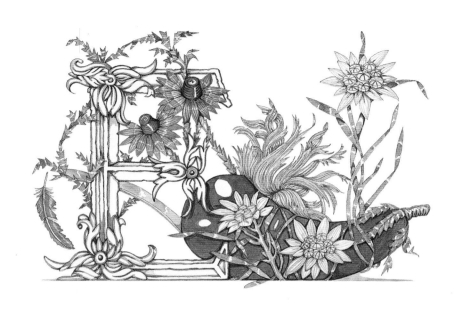

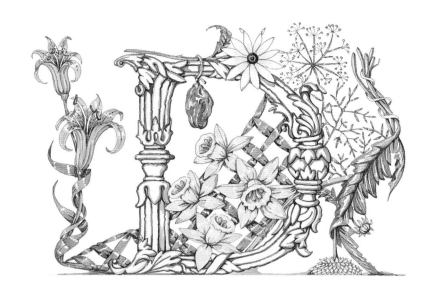

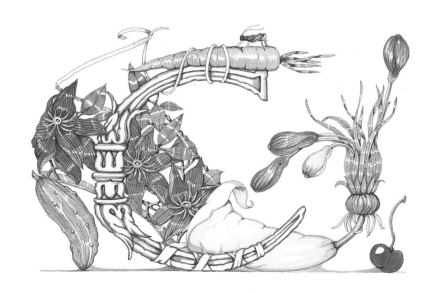

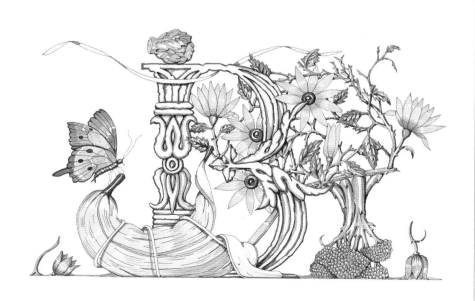

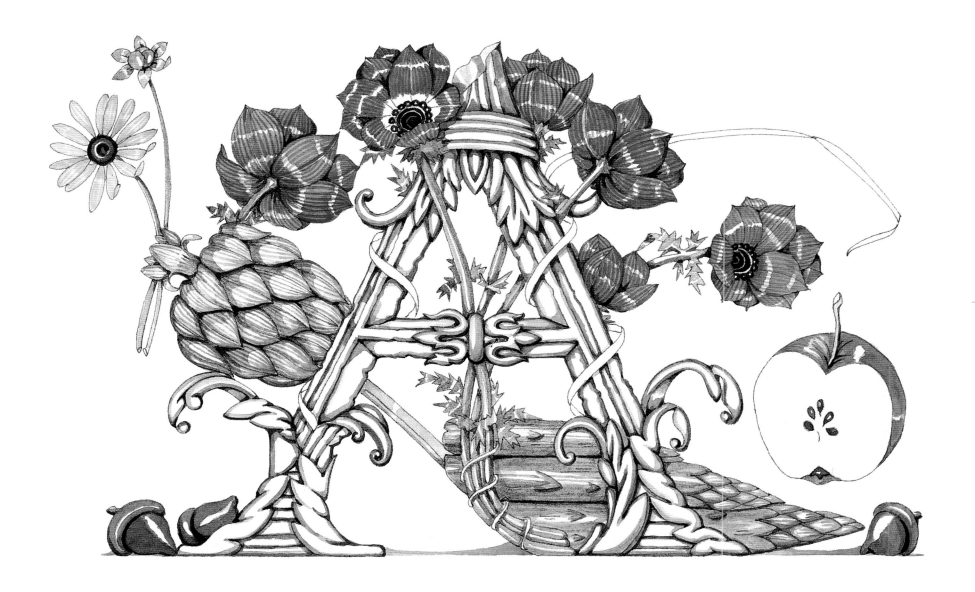

the *t*

HOLDS A

m a t o

SECRET

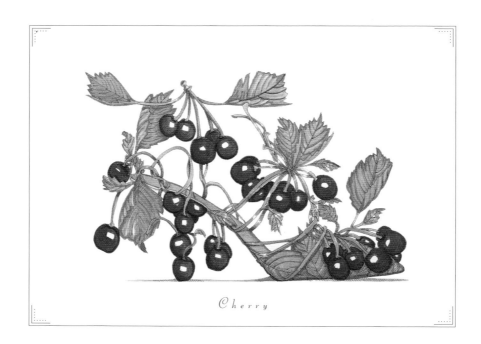

Cherry

{Not unlike the taste of a cherry...}

〜

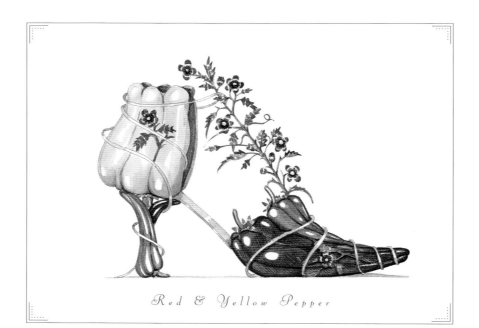

Red & Yellow Pepper

{...The bite of a pepper...}

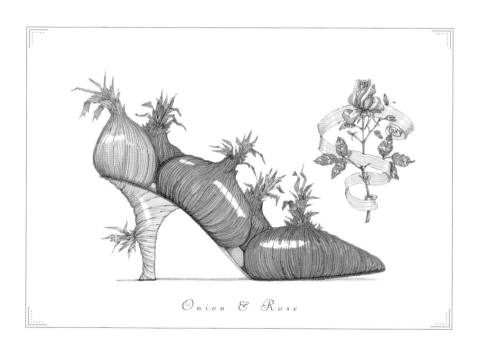

Onion & Rose

{…The tear from an onion…}

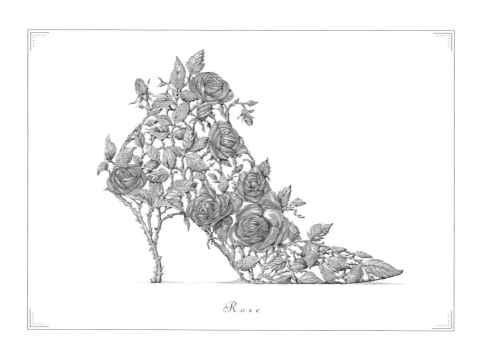

Rose

{...The scent of a tea rose...}

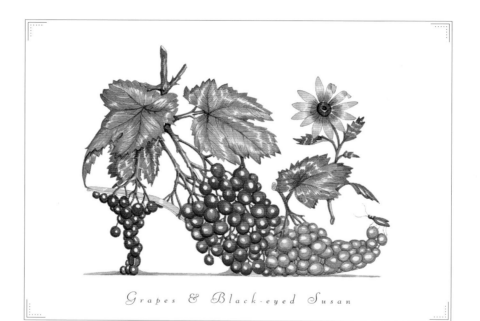

Grapes & Black-eyed Susan

{...The blush of a grape...}

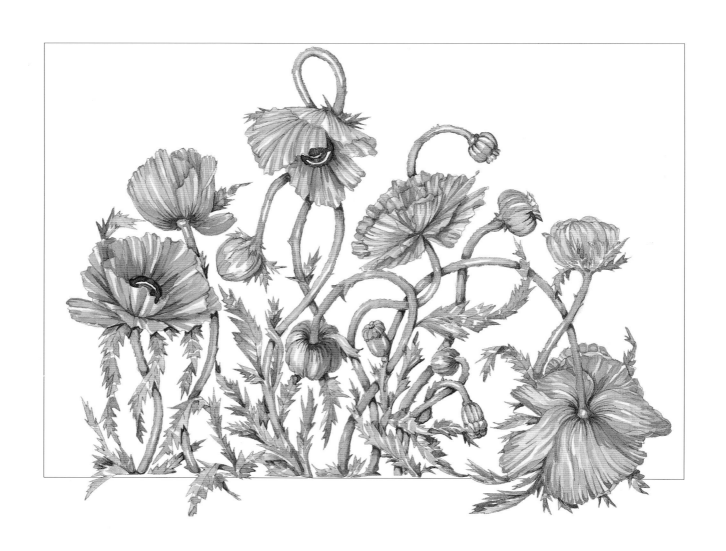

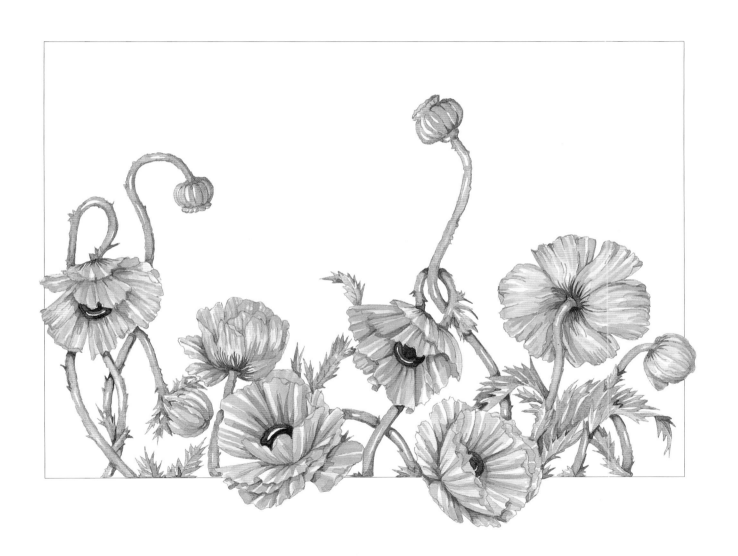

They called it "Peruvian Apple" (after its native country) and "Love Apple," no doubt, because it resembles the heart — drinking in sunlight, even moonlight. Ripening with passion, living under the summer sky, the tomato-heart calls out. A gathering force, like love itself, the tomato says nothing about its inner-life. Yet, one taste and the best-kept secret is revealed.

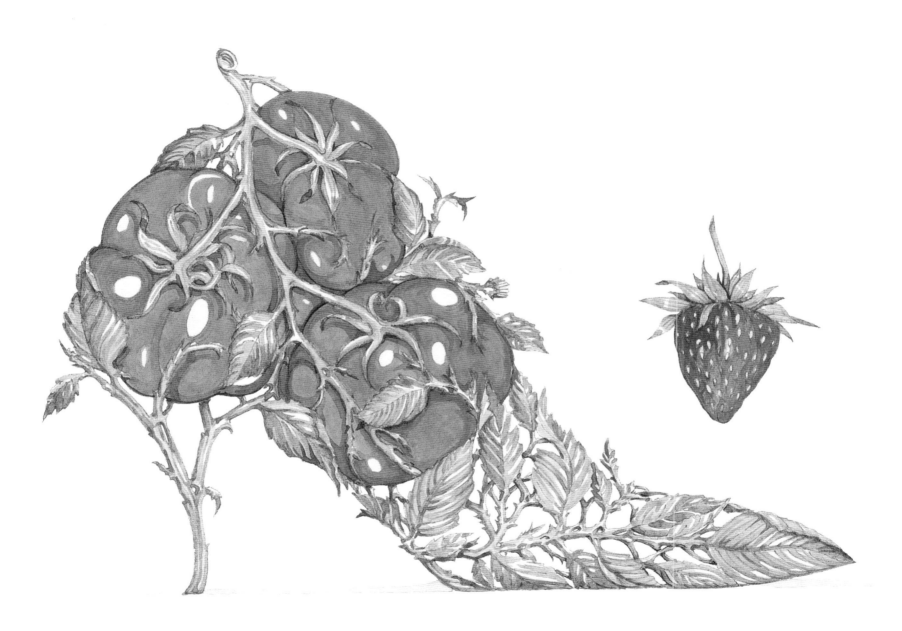

Tomato & Strawberry

SHOE

for co

THE

FIT

urting

MUSE

April, and the earth, still hard from winter's ice, seems contrary to any soft beauty. Unimaginably, the tulips rise up—almost overnight—changing the world with their gorgeous politics, their salient struggle. A bed of tulips appears an insurrection against dark seasons. After weeks of silence, the tulips bloom along the garden path. The gate is open, and the muse walks in.

✦

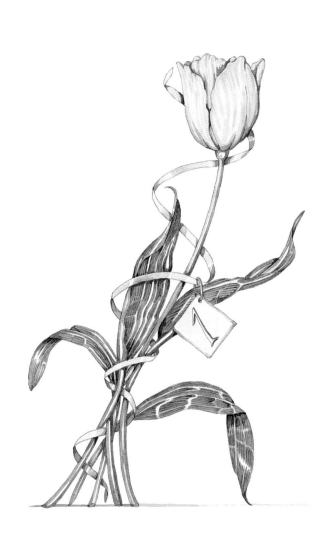

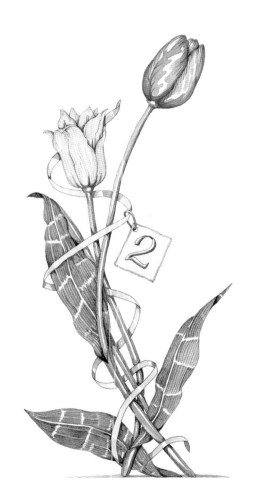

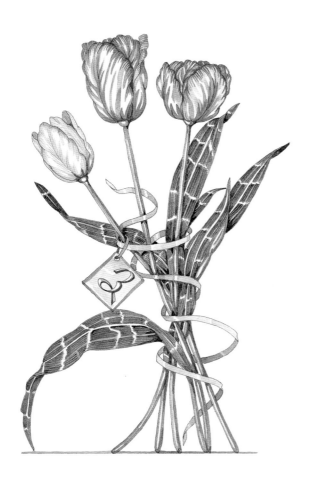

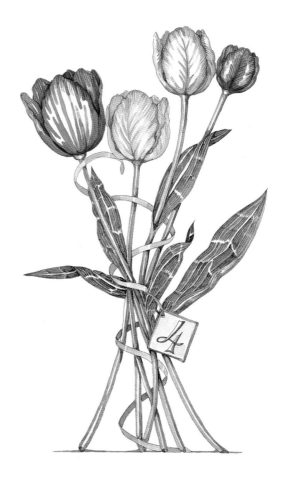

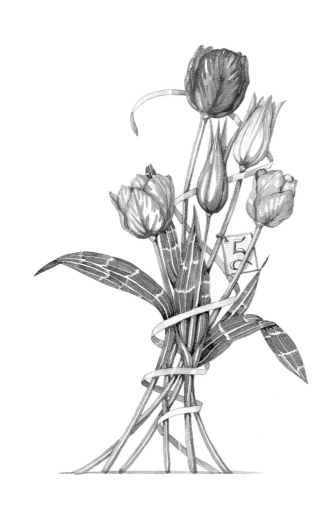

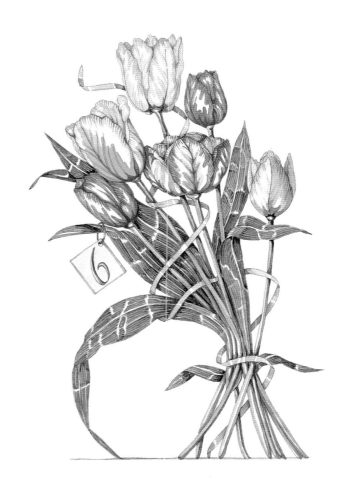

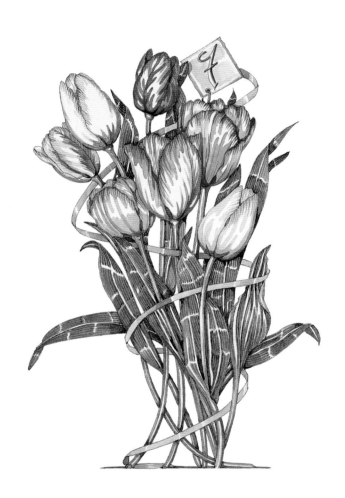

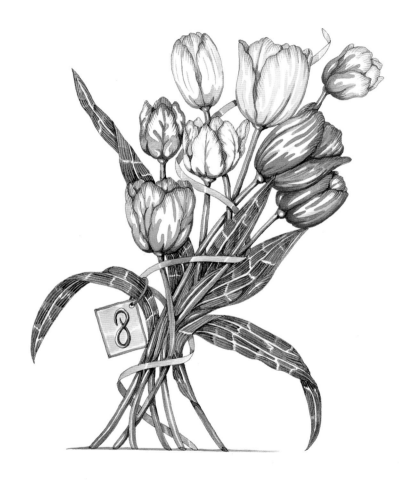

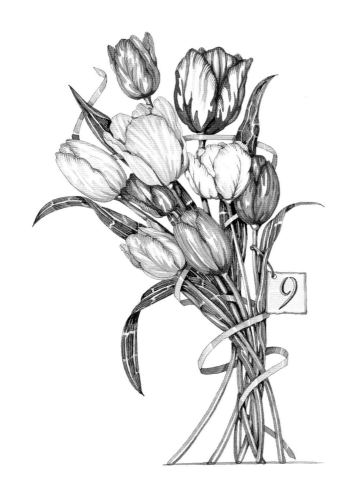

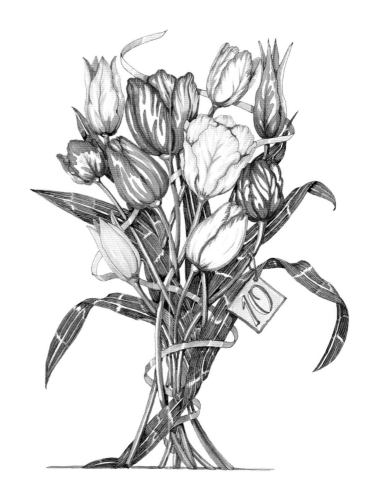

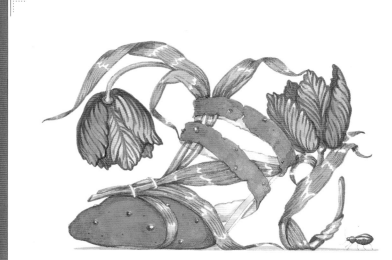

Potato & Tulip

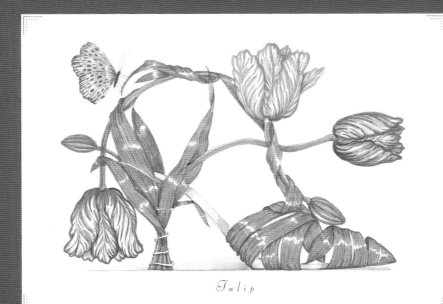

Tulip

The sunflower inspires the age-old question: Does character determine fate or fate character? Watch a field of handmaidens hold up mirrors for their Lady as she travels across the sky. Is it the sunflower's golden character that makes it so suited for this life? Or is it this daily routine that turns each flower into an image of the sun?

❧

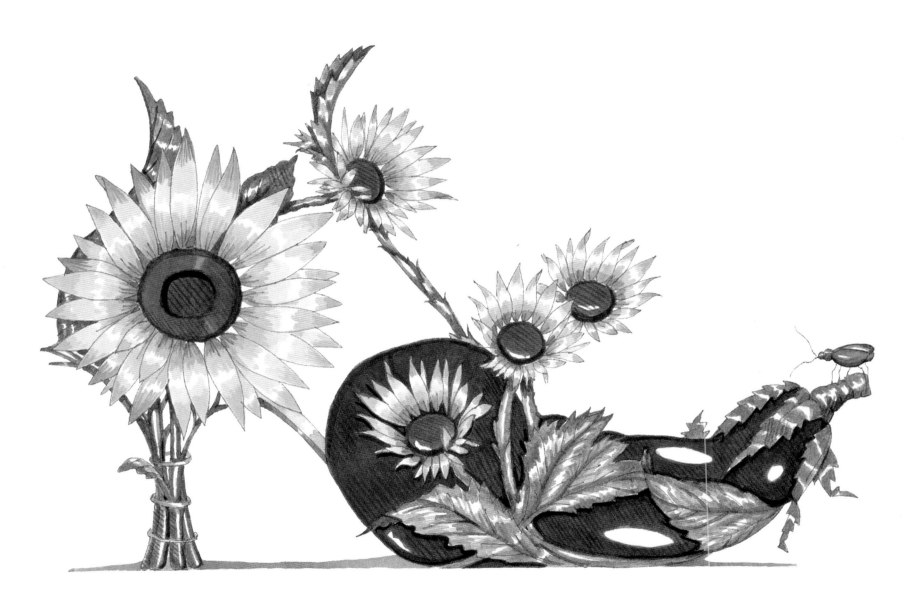

Eggplant & Sunflower

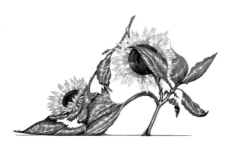
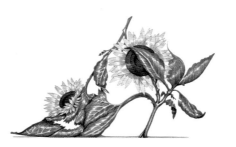
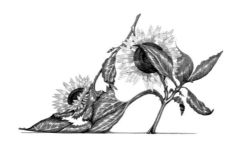
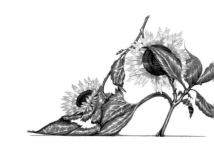
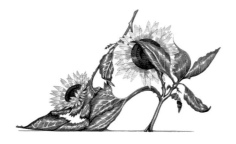
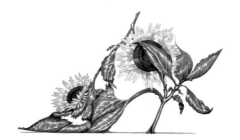
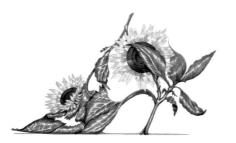
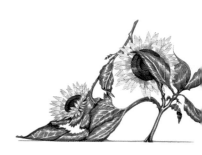

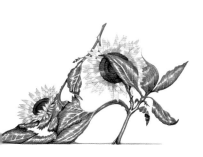

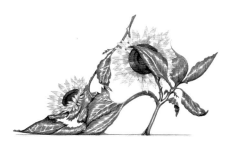

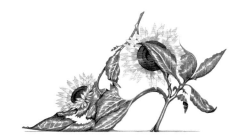

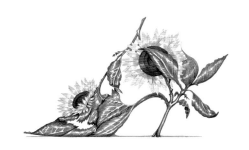

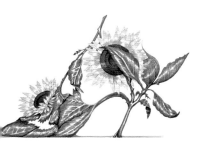

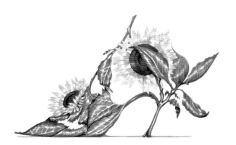

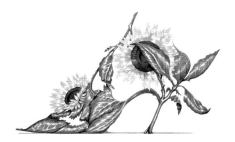

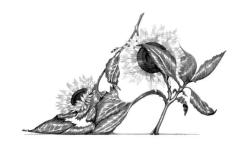

For centuries, the oil of the olive was burned in sanctuary lamps. On a moonlit night, one comes across a grove of olive trees, each studded with a galaxy of petite, silver spheres. The radiance of the olive can be eaten; always humble, the olive is a prize, treasured for its flesh, pressed for its oil. And on certain uncharted Mediterranean islands, everyone wears olive slippers.

❧

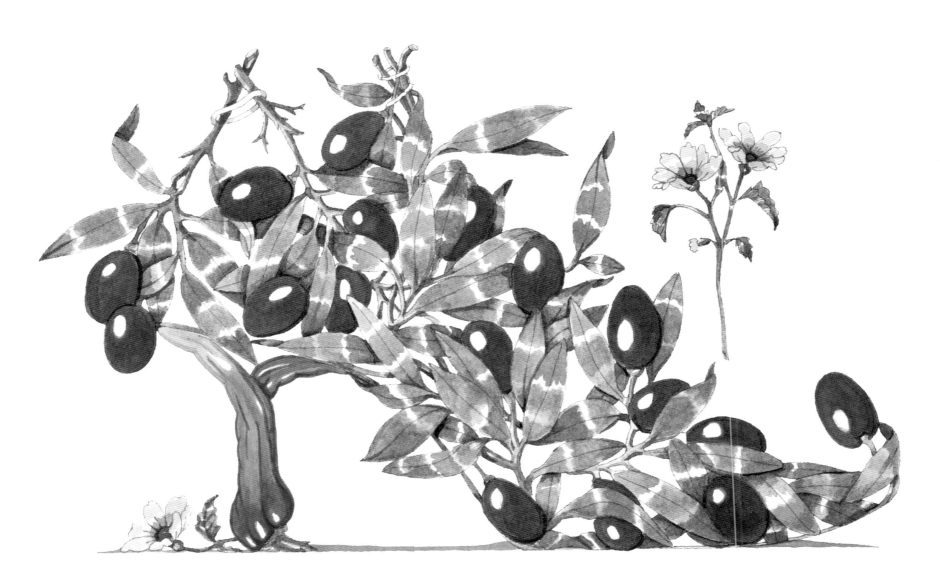

Olive & Pepper

It takes far greater courage to be ordinary than glorious. High up on its stalk, the artichoke appears to be royalty, first with a green crown, soon a lavender one, then a gold. But lo and behold, it is simply a thistle. Leaf after leaf, the artichoke builds a fortress around its center, carefully guarding what it holds most dear. Only after much persuasion, will the artichoke share its heart.

꩜

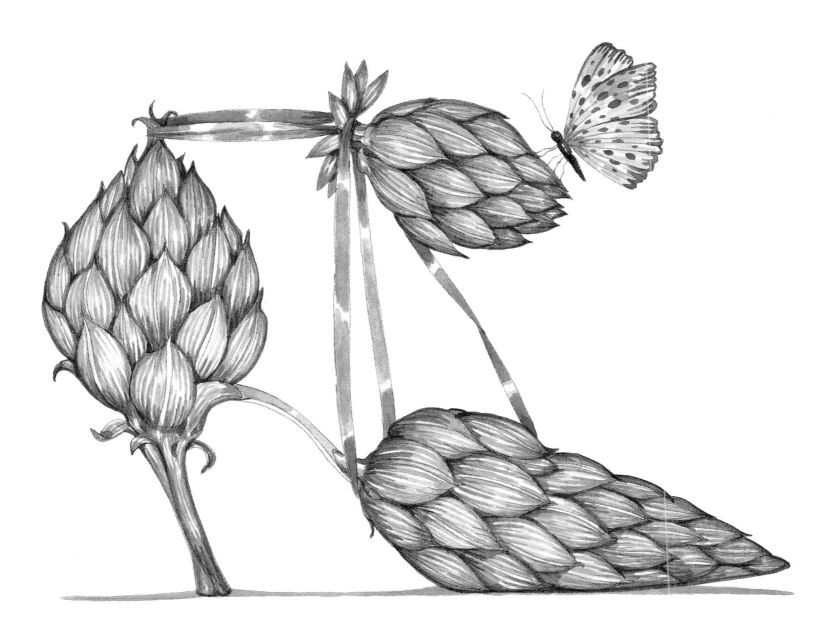

Artichoke

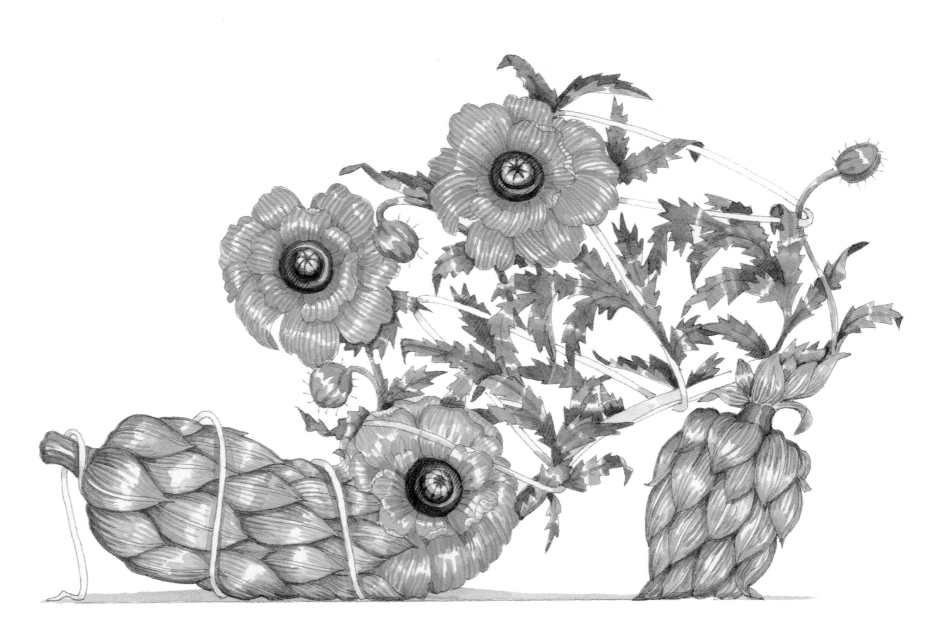

Artichoke & Poppy

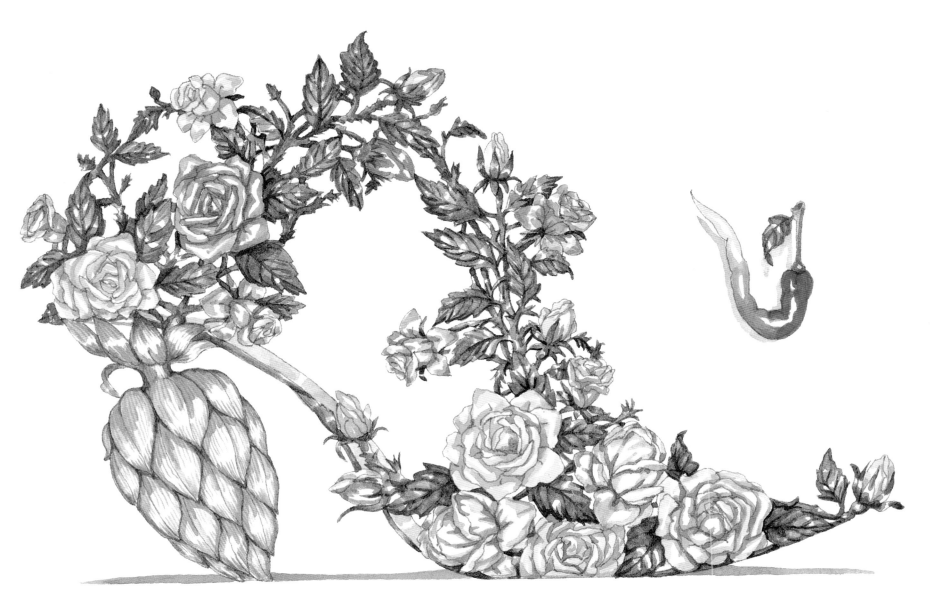

———
121

Rose & Artichoke

What's that there, below the snow, finding its way into the garden? Spring has barely taken a first breath, and a crocus breaks into this world the way a new idea enters the mind. Plant a border of crocus—each bloom starting from a tiny bulb—and you'll see a string of lights. What a delight! What a metaphor for fresh thinking. What a breakthrough.

✦

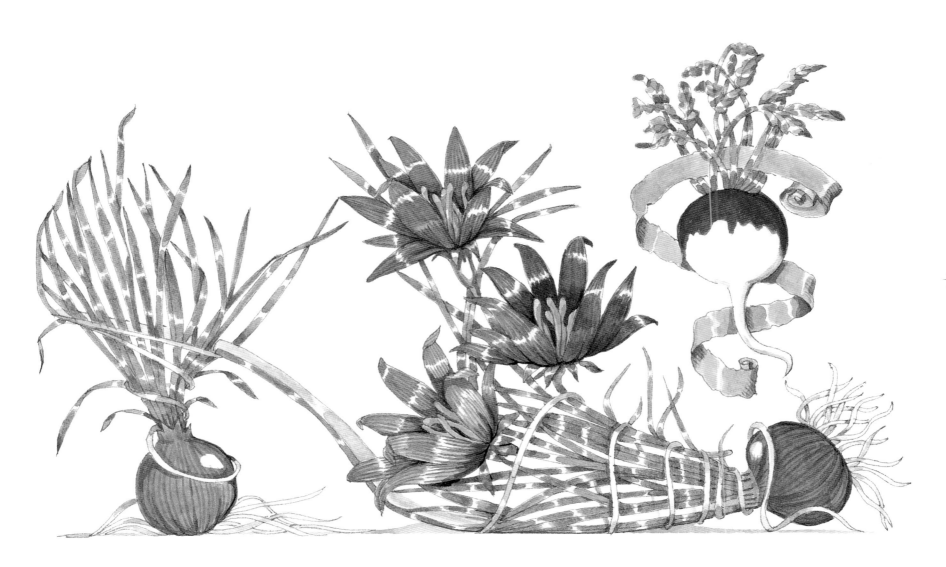

Crocus & Radish

Finally, winter's plot is resolved, and fig leaf, rose leaf, maple leaf say *yes*. Soon, leaf after leaf, we read the pages of the seasons, a garden unfolds. A wall of leaves becomes a bright, green waterfall. Then, on a clear, crisp morning you hear her footfall, everywhere. Fall arrives—wearing shoes made solely of leaves, walking down every empty street.

<center>⁙</center>

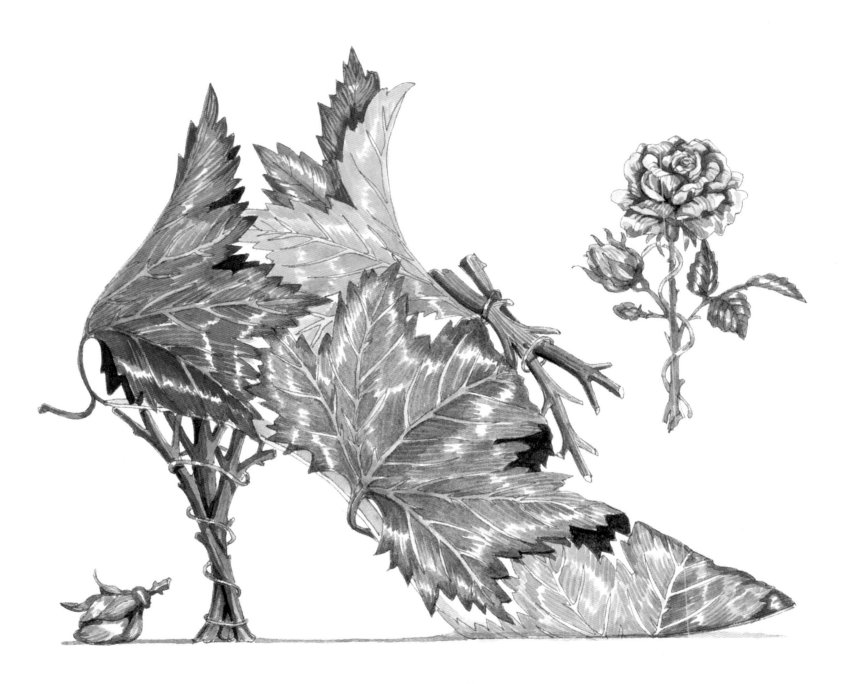

Maple Leaf & Rose

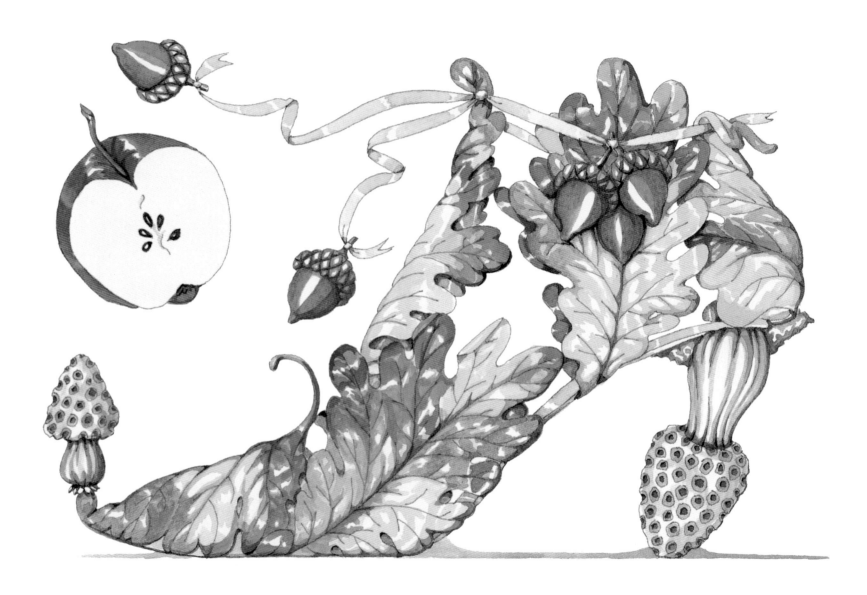

Oakleaf, Apple & Morel

A tropical beauty, with lovely hands, the banana tree is really a bush with long, lush leaves perfect for making weatherproof roofs on jungle huts. But, it is the banana tree's delectable fingers, its fruit, that we are after. Peel one, and there, beneath the golden skin, you'll discover all the sweet languor of equatorial heat.

❧

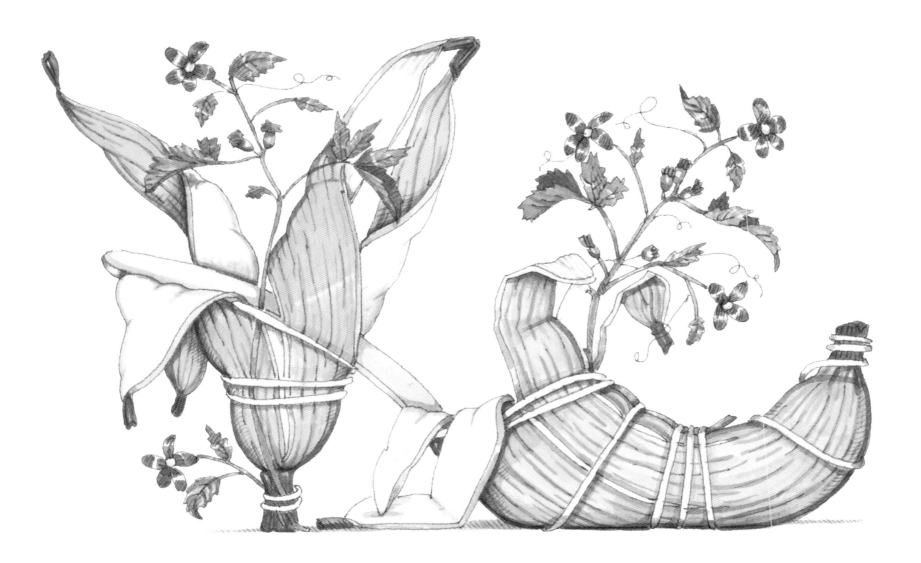

Banana

THE CON
of
COM
o f
p e

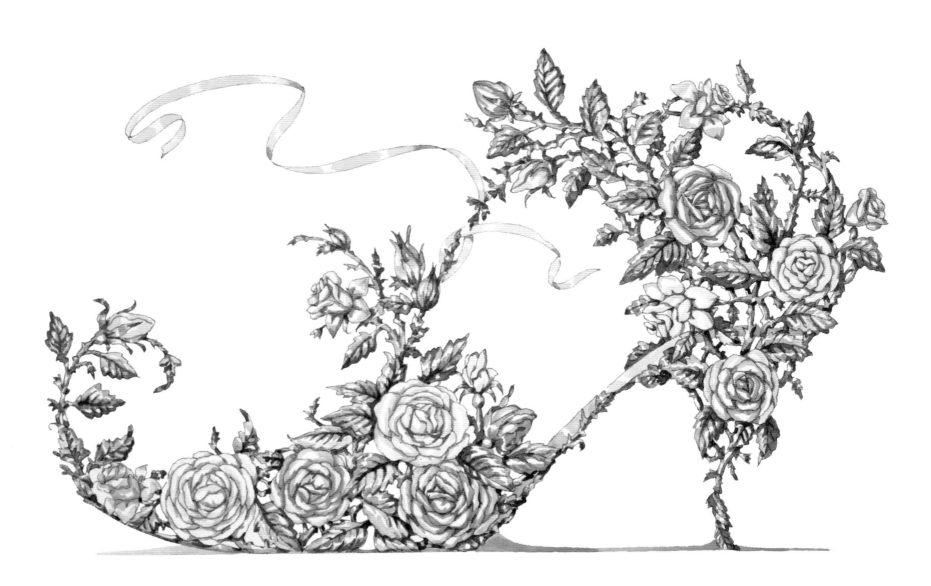

Rose

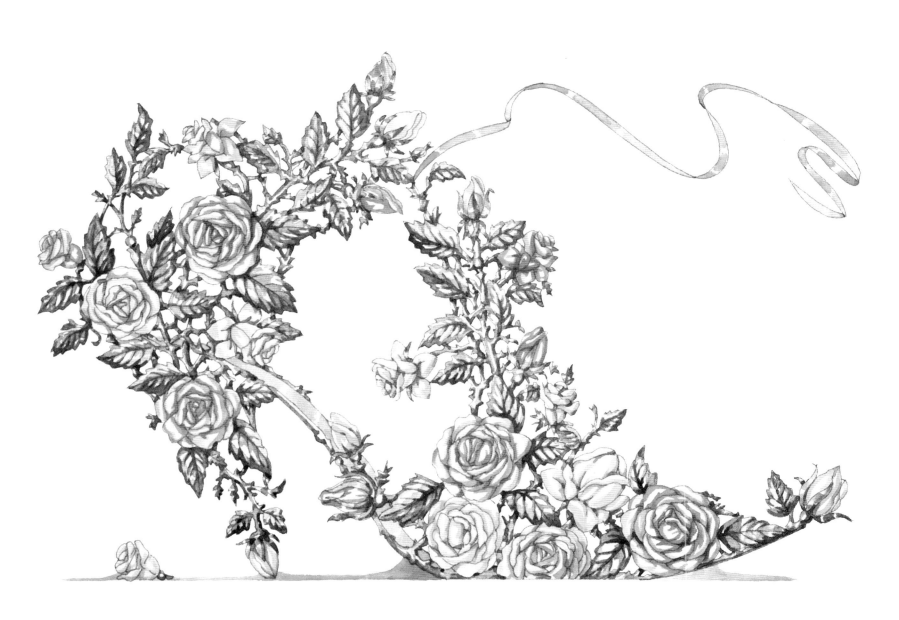

Rose

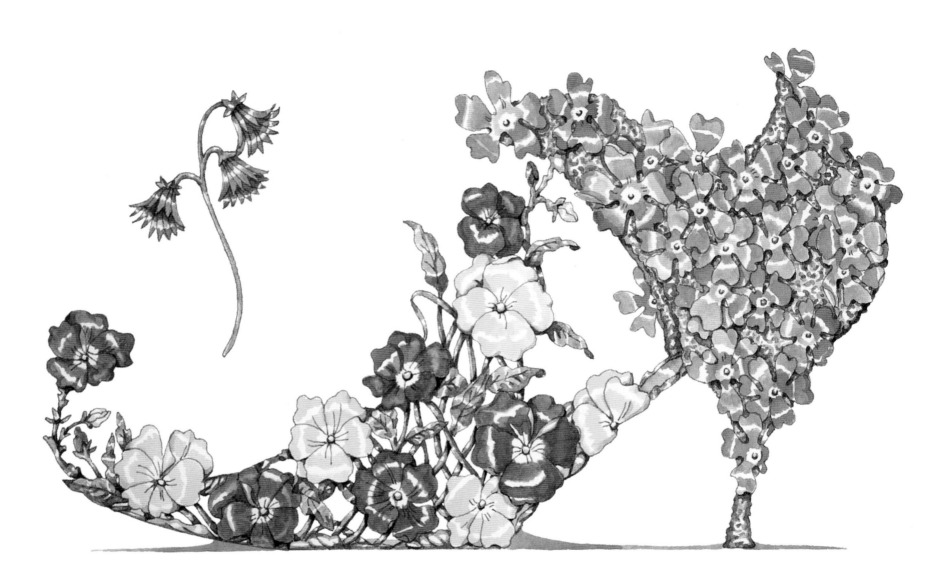

Alpine Pansy & Primrose

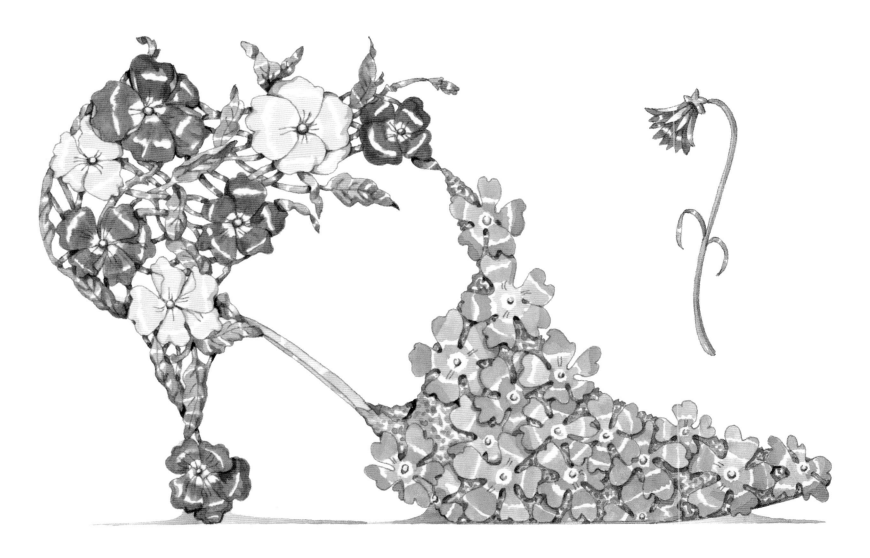

Alpine Pansy & Primrose

Wandering down a hallway of jasmine, you pause in the perfume of moonlight and reconsider the limits of the sensual world. Tuberose, gardenia, lily—the white flowers call you back from the practical, leaving you stranded on an island of mop-topped palms and a big-hipped moon. Once there, you can't tell where the fragrant air stops and your body begins.

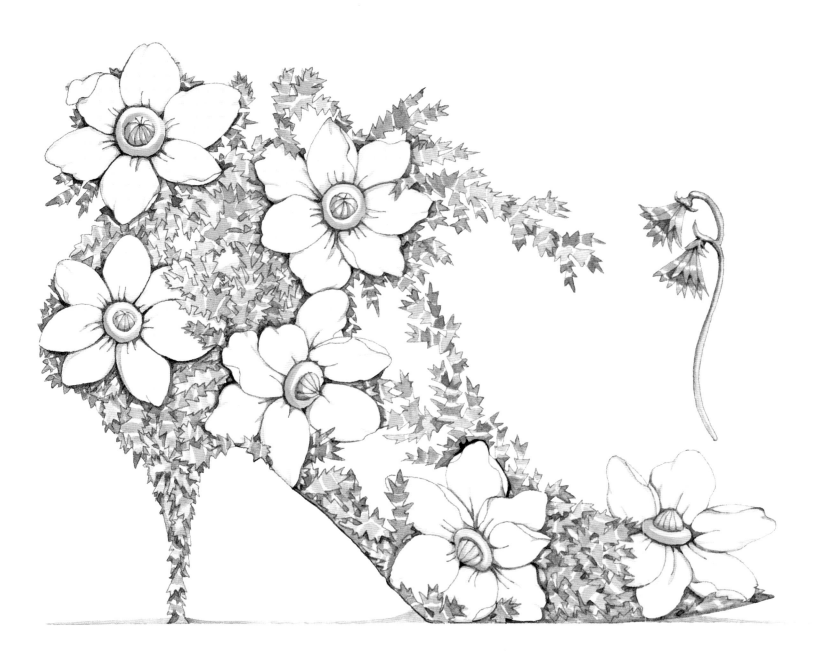

Alpine Anemone

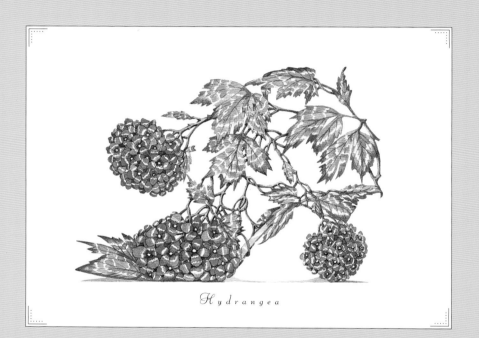

Hydrangea

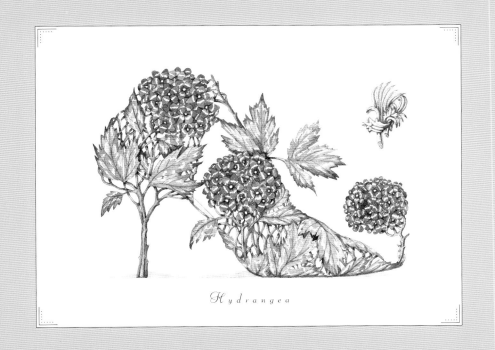

Hydrangea

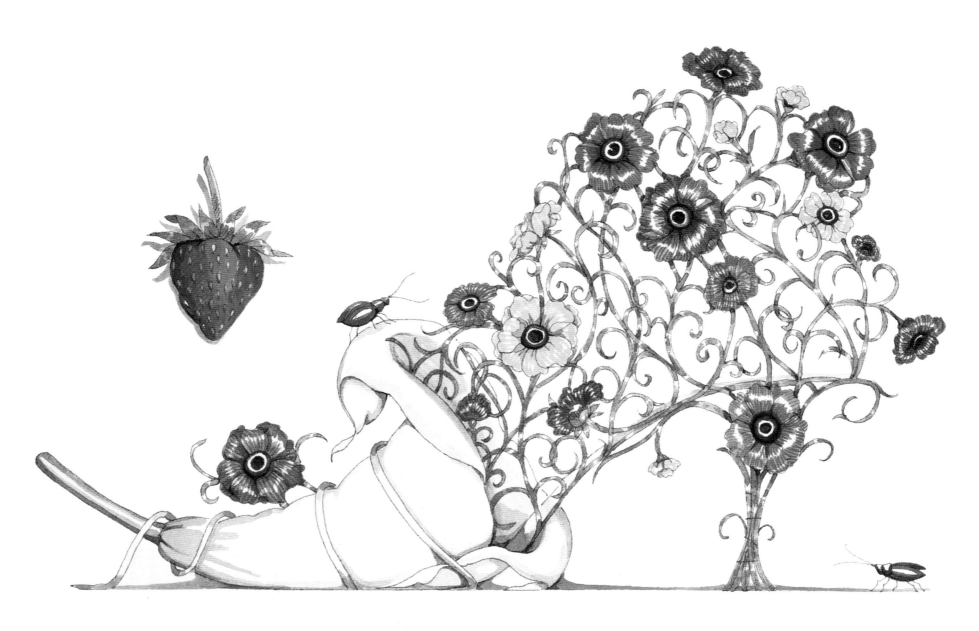

Calla Lily, Coreopsis & Strawberry

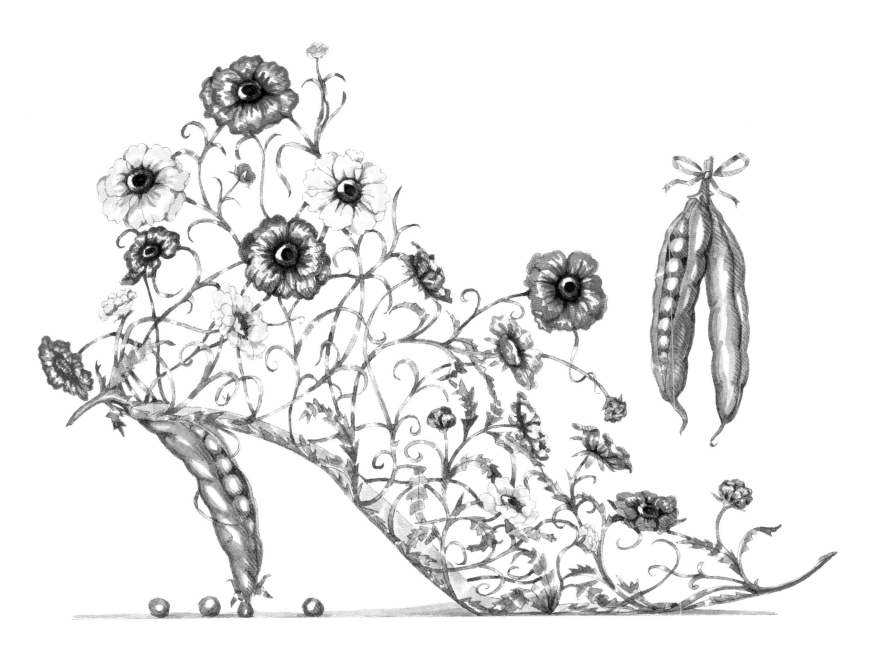

Coreopsis & Peas

A melody

OF FLOWERS AND

cherry

BELLS.

❧

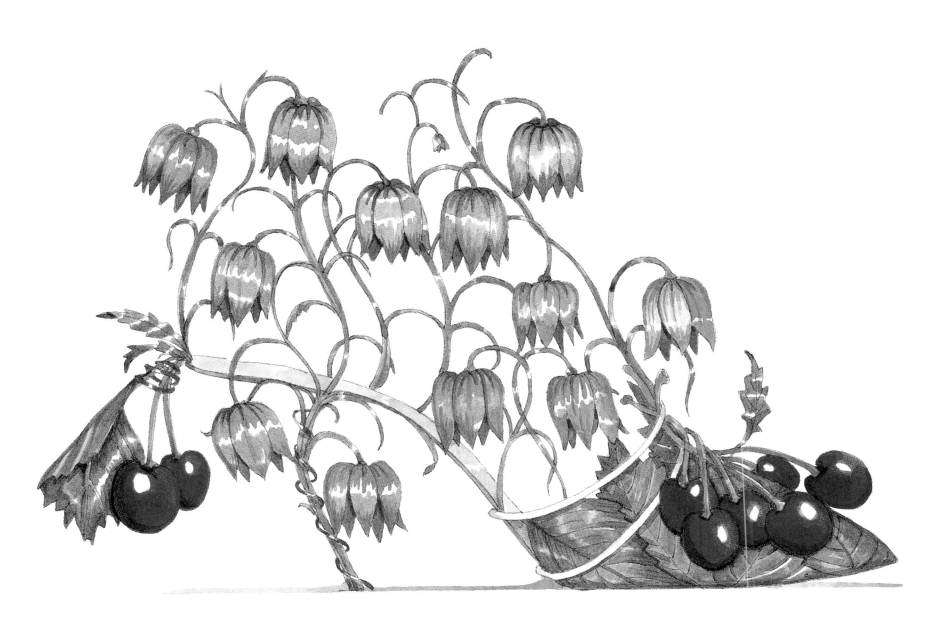

Fritillaria & Cherry

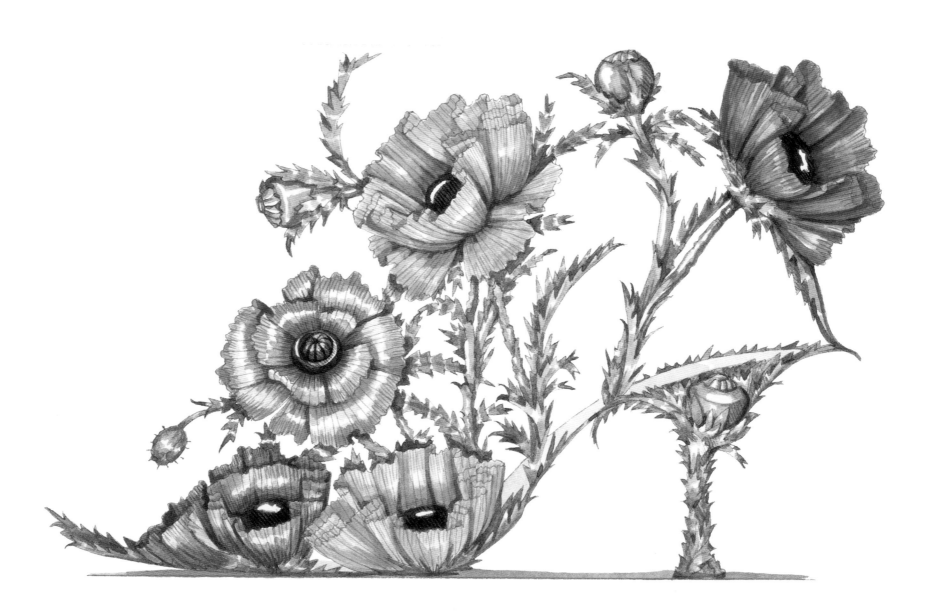

Poppy

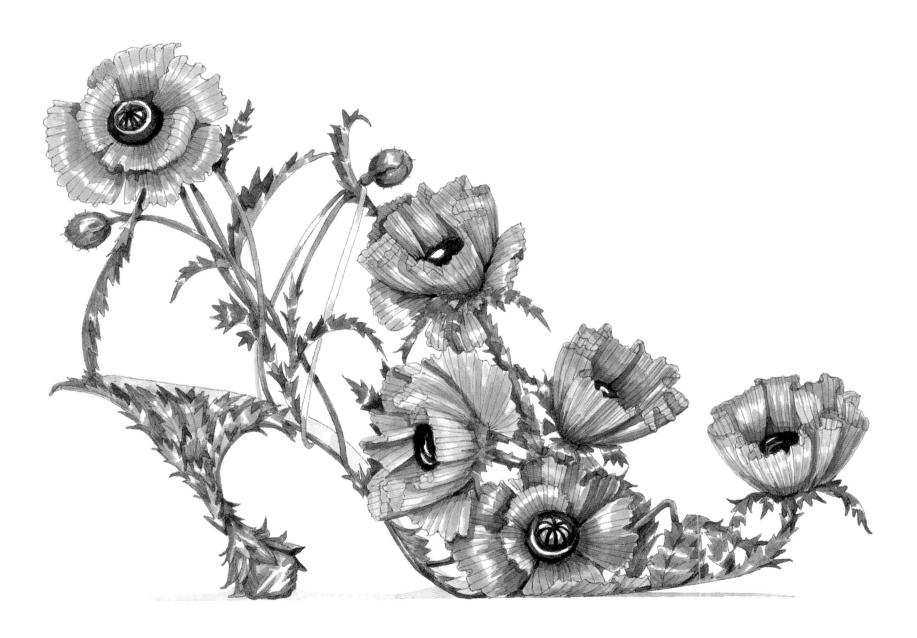

Poppy

Despite all that it initiates: Spring, love, remembrance, the rose is the final flower. Not even the tall, glamorous gladiola evokes more joy—nor the lily more melancholy. Every petal conspires against death, every thorn against indifference, and every leaf shakes like green foil. In the garden, the rose has the last word.

⁓

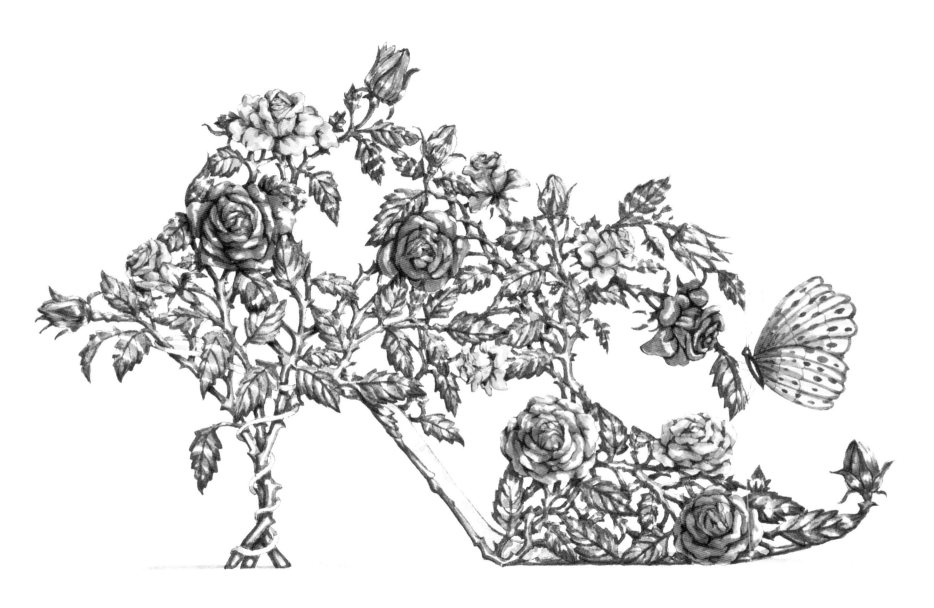

Rose

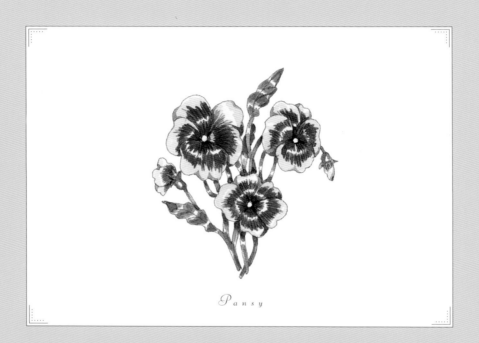

Pansy

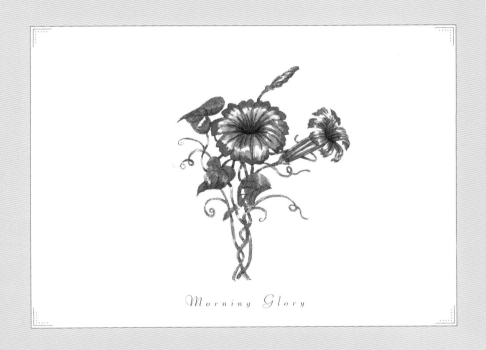

Morning Glory

You can chase it from your garden, but pull up vinca (also known as periwinkle) and in a wink, it will be back. Vinca clings to walls, fences, hillsides, creek banks, pathways—vinca is not fussy. Vinca's a simple, country girl looking for a husband out there in the world, looking for a quarter-acre to call her own—happy, blue-capped children running her wild.

—•—

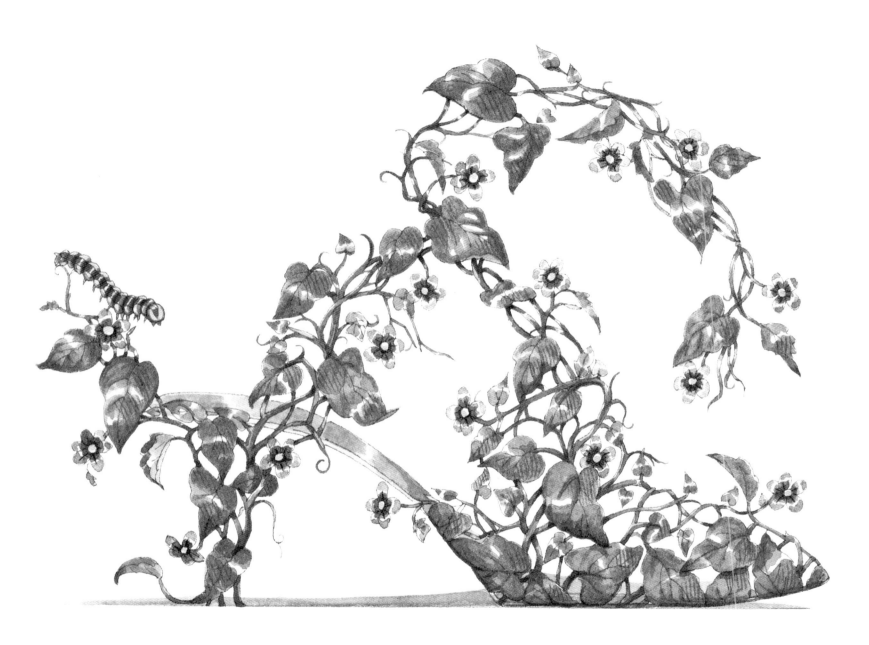

Vinca

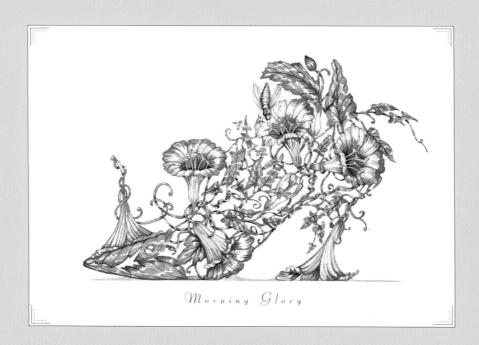

Morning Glory

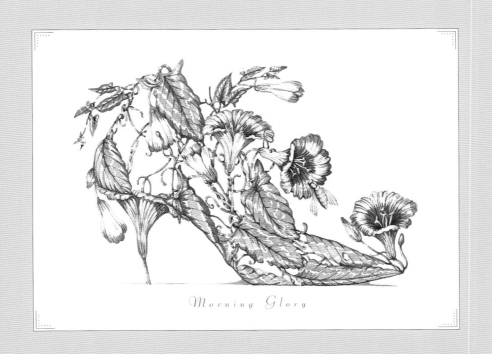

Morning Glory

About
LOVE — ONLY THE
daisy knows
THE TRUTH.

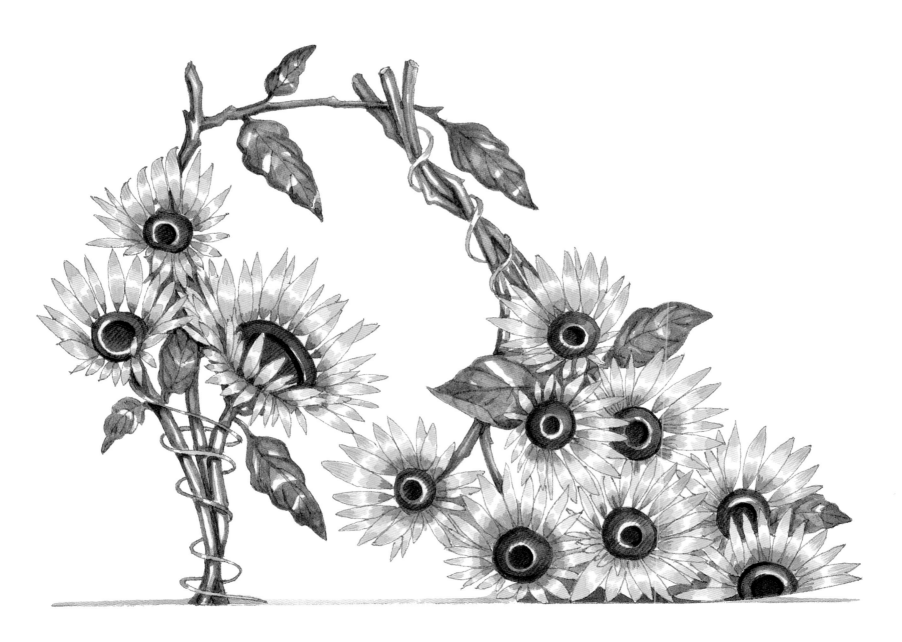

Black-eyed Susan

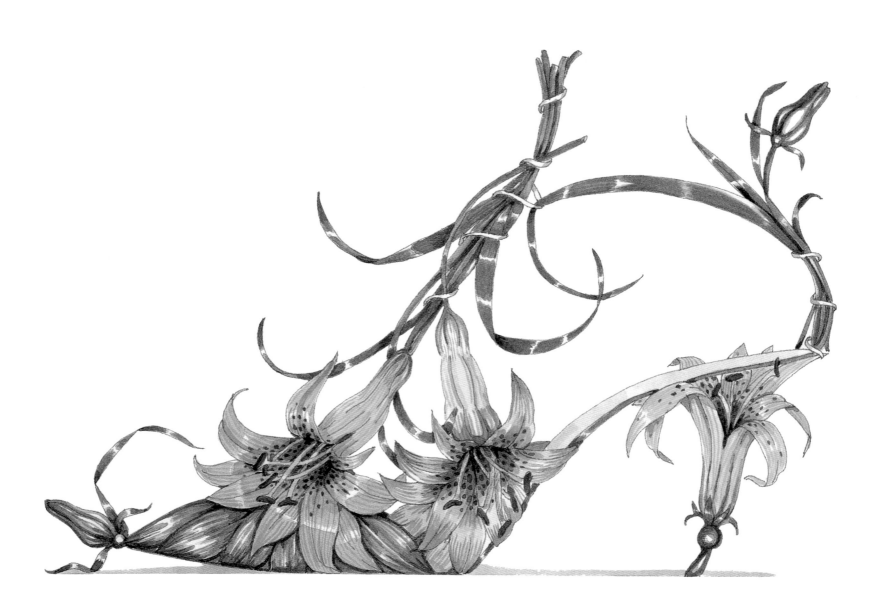

Day Lily

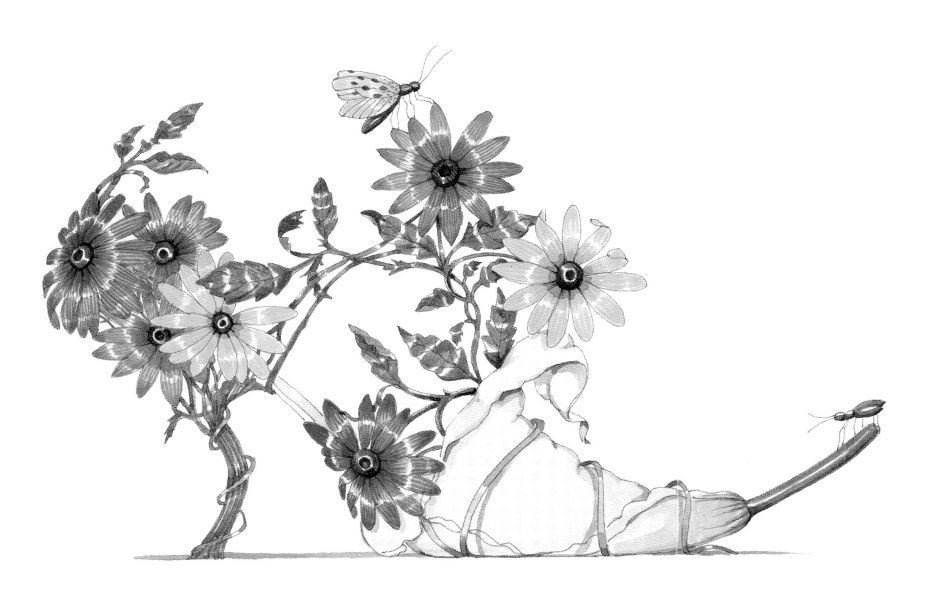

Calla Lily & Daisy

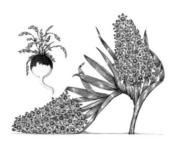
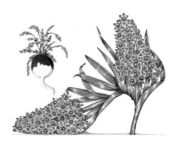
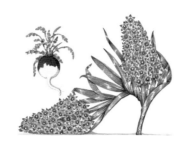
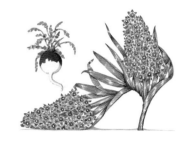
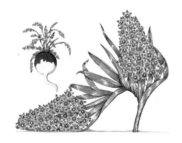
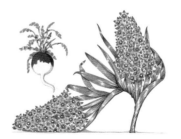
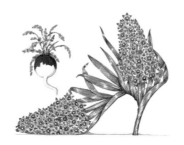
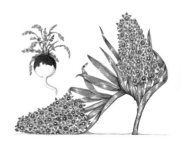

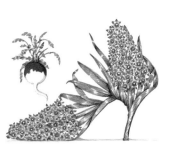

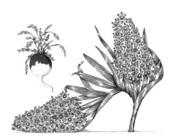

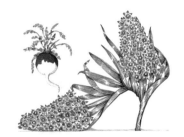

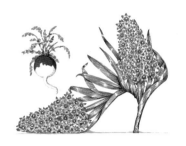

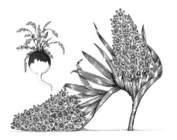

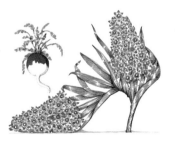

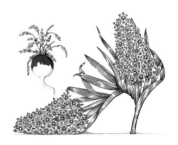

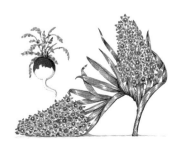

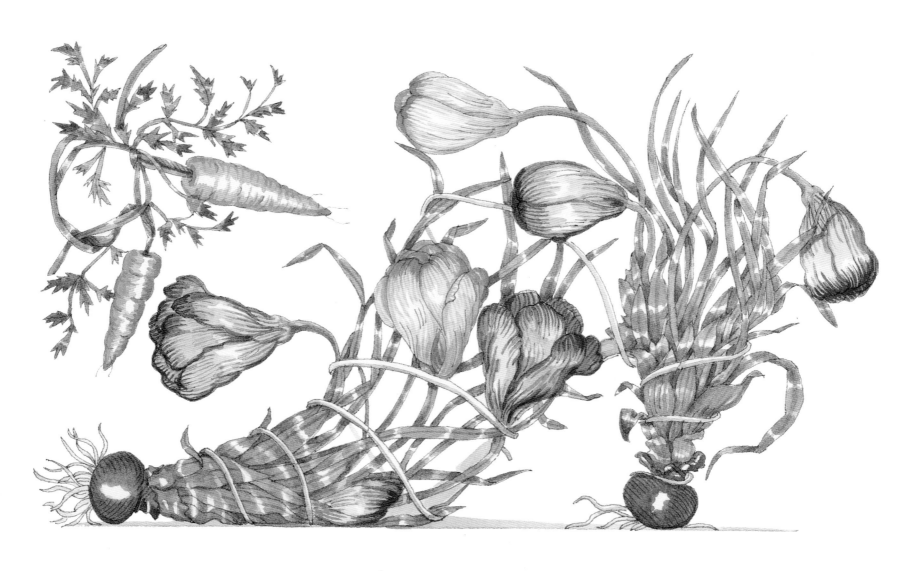

Crocus & Carrot

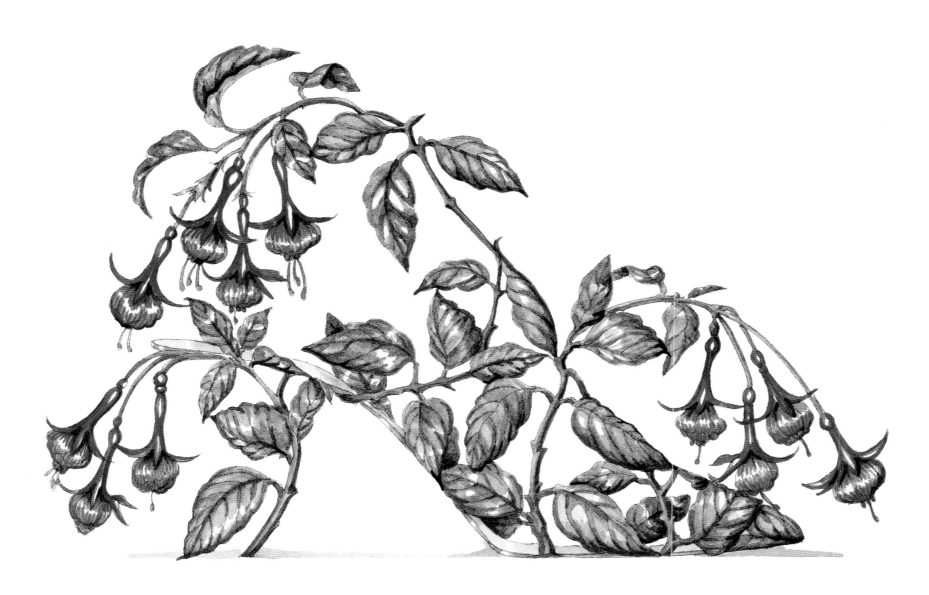

Fuchsia

Nodding

IN AGREEMENT,

the daffodils

SIGH WISTFULLY.

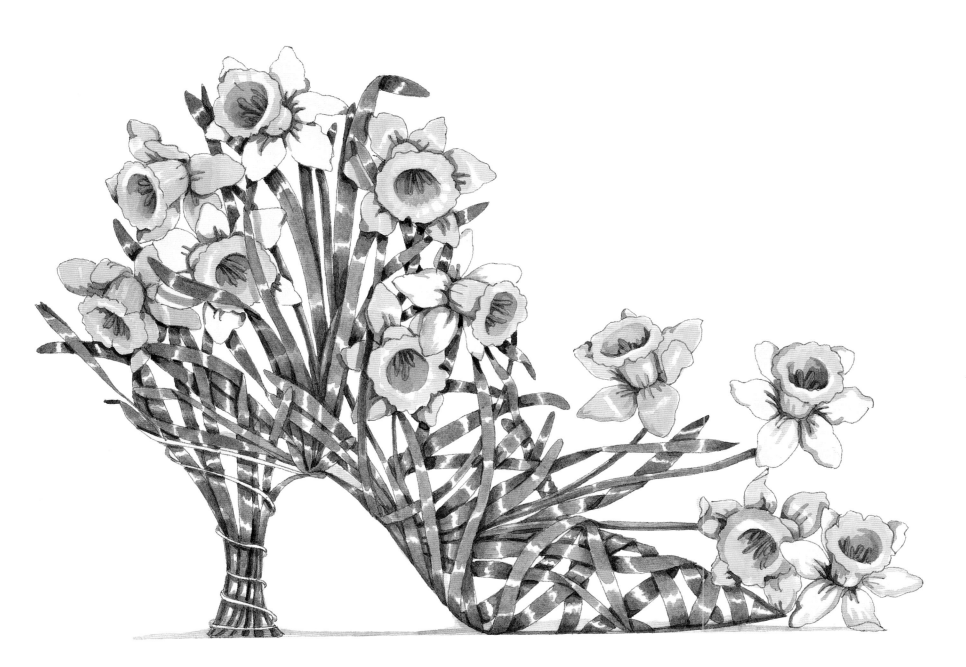

Daffodil

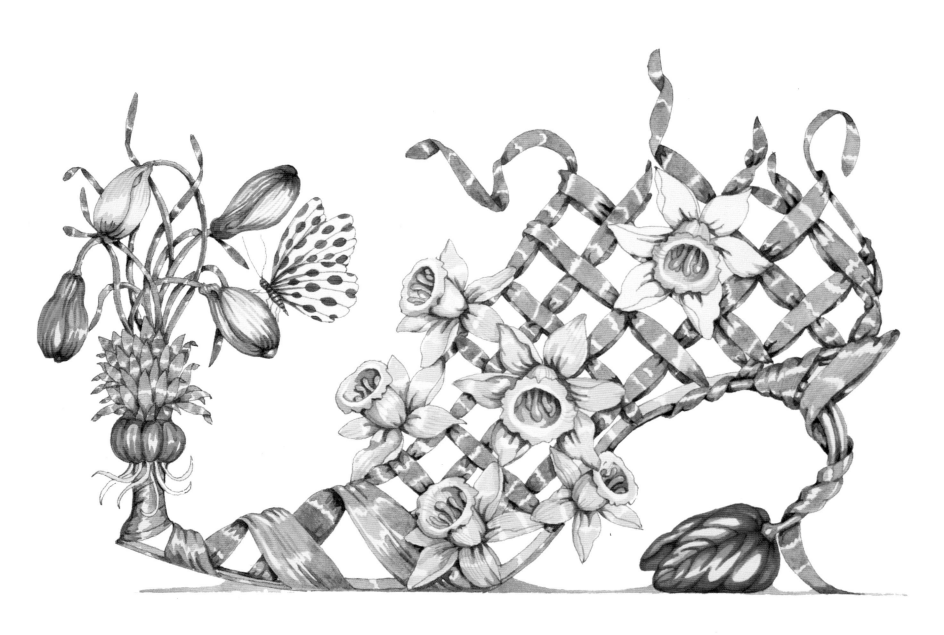

Crocus, Daffodil & Tulip

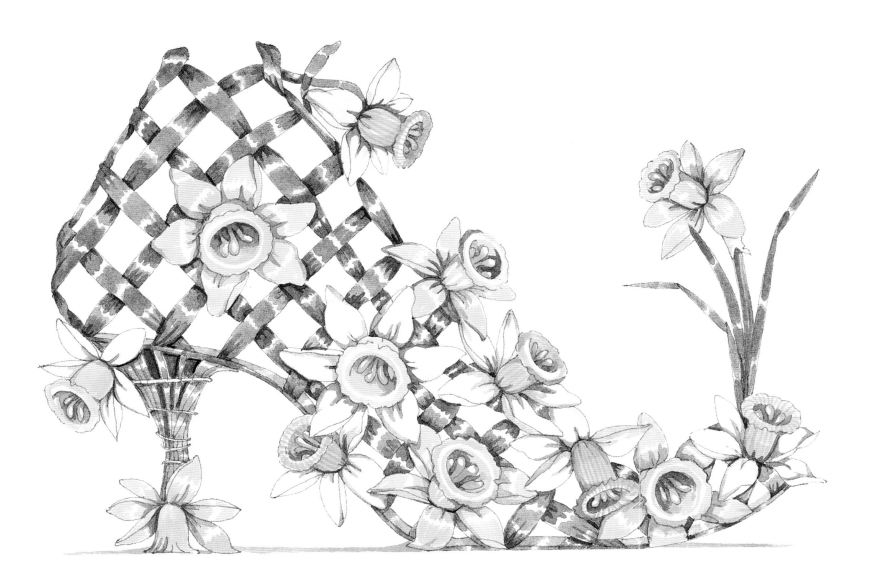

Daffodil

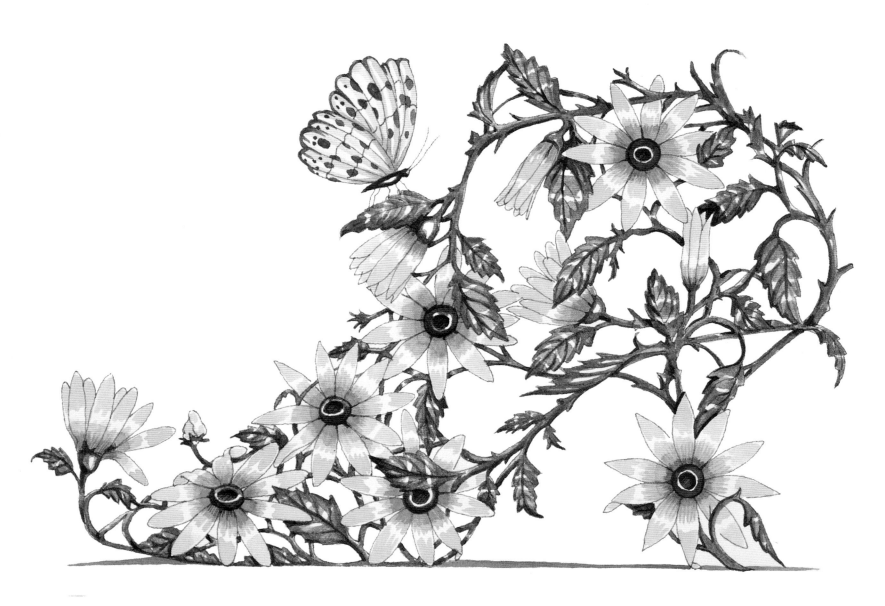

Black-eyed Susans

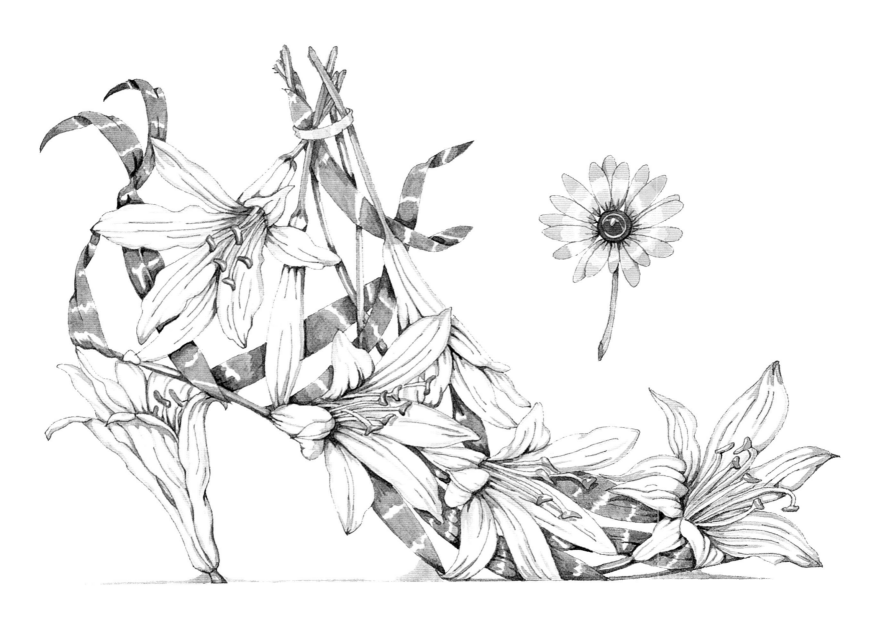

Alpine Lily

Aruffian, garlic, with a head full of ideas. A favorite from the edible garden. Foliage like a green fuse, garlic sits beneath the earth, ticking with potential. Very seldom reserved—pull garlic up, bring it into the kitchen, and, once you remove its paper jacket, garlic takes action, turning all those wild thoughts into a passionate, savory love.

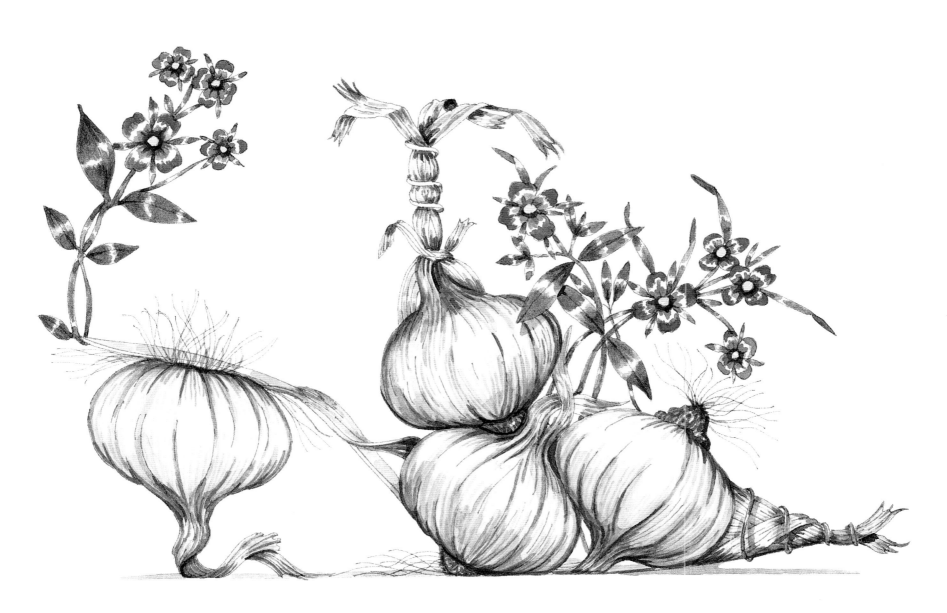

Garlic

I wear a serious jacket in life.
But what would often appear severe is delicately lined
with the vibrant, embroidered words of the
ancient Chinese writer, Wu-Men.

TEN THOUSAND FLOWERS IN SPRING,

THE MOON IN AUTUMN,

A COOL BREEZE IN SUMMER, SNOW IN WINTER.

IF YOUR MIND ISN'T CLOUDED BY UNNECESSARY THINGS,

THIS IS THE BEST SEASON OF YOUR LIFE.

I am deeply appreciative of Hebe Dorsey and Diana Vreeland for revealing
the magic and wonder of the shoes designed for Roger Vivier. As each slipper was carefully
unwrapped and placed before me many years ago, I wondered at the imagination, the architecture
and the wit. That afternoon in the basement of the archives of the
Costume Institute at the Metropolitan Museum of Art changed forever the way I look at shoes.

It is equally important to acknowledge many for their encouragement
and generosity, beginning with Dodie Kazanjian, Glenda Cudaback, Dale Kern, Brooke Hayward Duchin,
Nancy Whitney, Geraldine Stutz, Marian McEvoy, Jane Stubbs, Martha Phillips,
Lynn Manulis, Candy Pratts Price, Debra Aleksinas, Nancy Lindemeyer, Suzy Taylor,
Carolyn Walsh, Jane Wald, Susan McCone, Stephanie Hoppen
and Timothy Mawson.

I continue to be inspired by the works of Diane Ackerman
and appreciate the clarity with which she captures the essence of sensuality
and our natural world in her book, *A Natural History of the Senses.*

And I especially wish to thank the talented book team…
Kristin Joyce of Swans Island Books, Marta Hallett and Elizabeth Sullivan at Smithmark Publishers,
Madeleine Corson of Madeleine Corson Design and Stefanie Marlis.

It also goes without saying that every artist is influenced by not only people but places.
I would like to mention the creative inspiration drawn from visits to Takashimaya in New York City,
Christian Tortu in Paris, Pulbrook and Gould in London, The Brooklyn Botanic Garden in New York,
Kykuit Gardens in Tarrytown, New York, and Moss Temple in Kyoto, Japan.

Dennis Kyte is renowned as an artist, illustrator and designer.
Beginning as an art director for Leo Burnett Advertising and CBS television,
Kyte now runs his own design firm, Dennis Kyte Inc. His clientele includes Estee Lauder,
The GAP, Whitney Communications, Fieldcrest and Stuart Weitzman. He has written and
illustrated several original children's books, including *The Last Elegant Bear,*
To The Heart of a Bear and *The Adventures of Puppy: A Gentleman Rabbit.*
The portfolio of *Botanical Footwear* watercolors has been exhibited throughout
the United States and Europe and his work is in the permanent collections of the
Smithsonian's Cooper-Hewitt Museum and the Brooklyn Museum.
He lives in Washington, Connecticut.

Swans Island Books, located in Belvedere, California, has produced
imaginative and insightful illustrated works for adults and children since 1990.
Established and directed by author and book packager, Kristin Joyce, the company has
to date created twenty-five illustrated books along with book-related merchandise and
museum exhibitions. Swans Island Books draws on the vast contributions of
illustrators, photographers, writers and designers located
throughout the United States, Europe and Asia.

Madeleine Corson has been creating internationally award-
winning print work, book design and packaging for over fifteen years.
She lives, works and walks her dog in San Francisco.